HARD GROUND

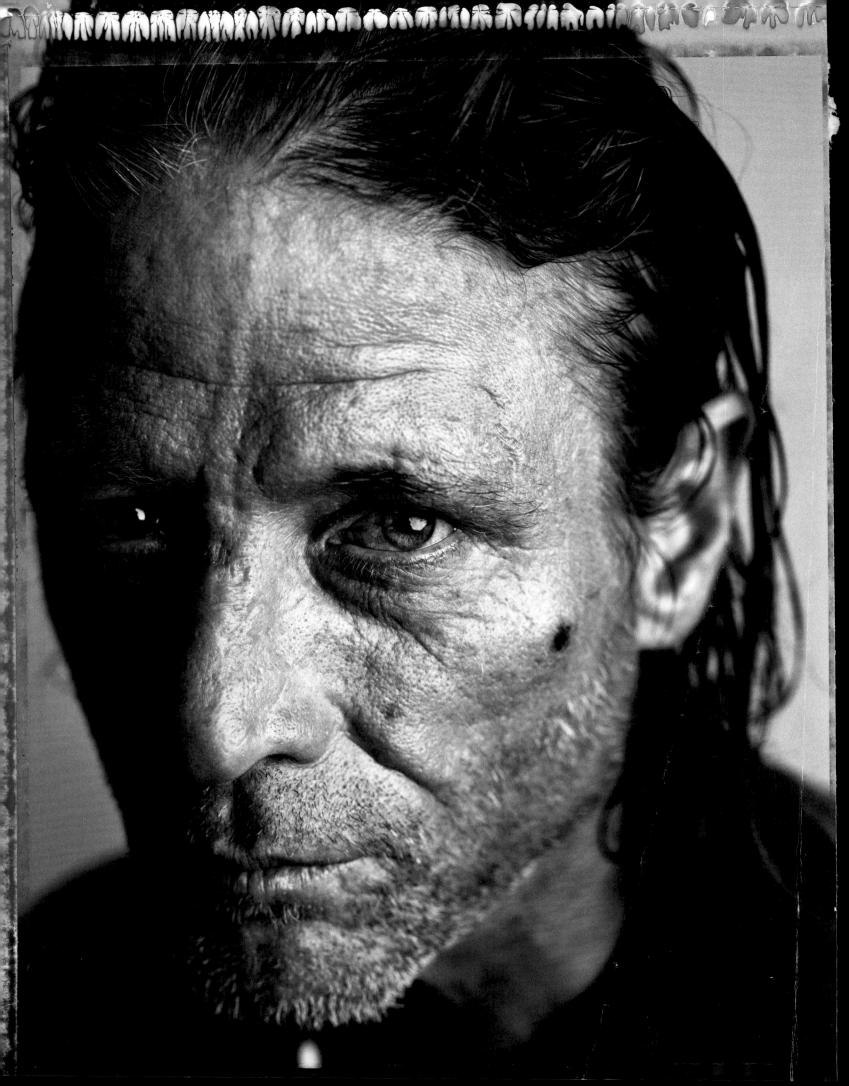

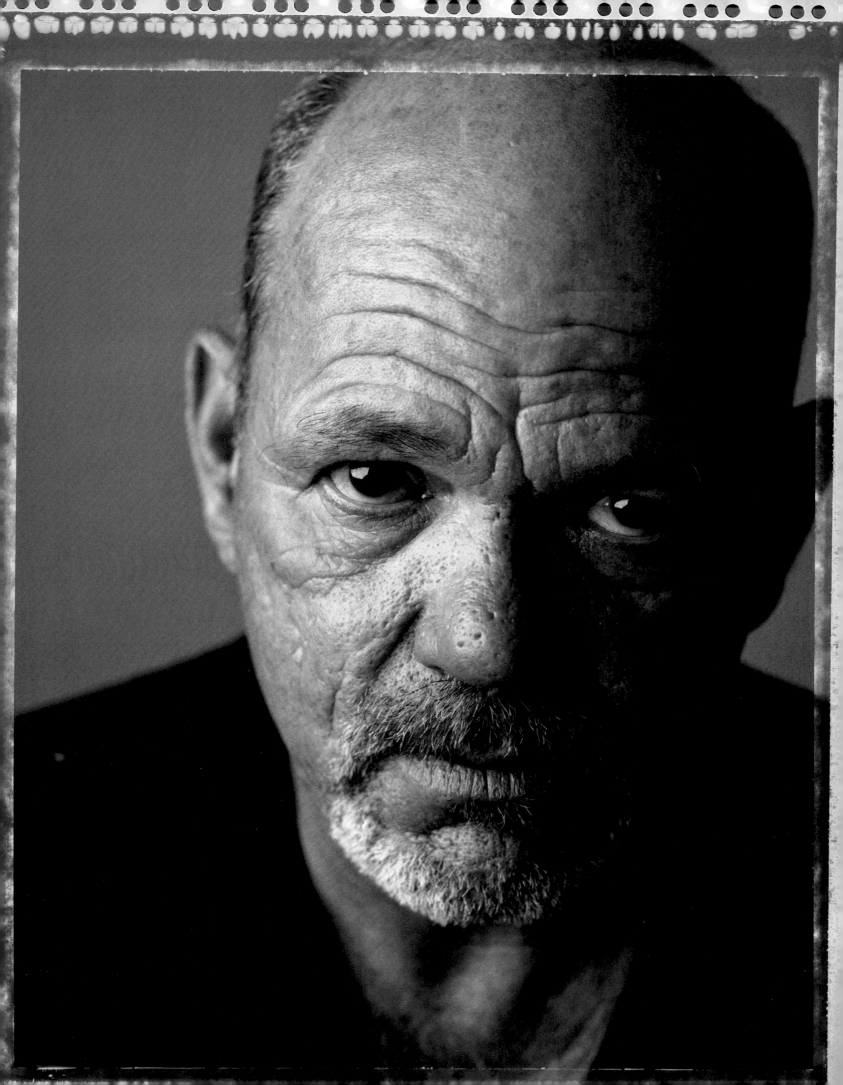

HARD GROUND

PHOTOGRAPHS BY MICHAEL O'BRIEN

POEMS BY TOM WAITS

UNIVERSITY OF TEXAS PRESS, AUSTIN

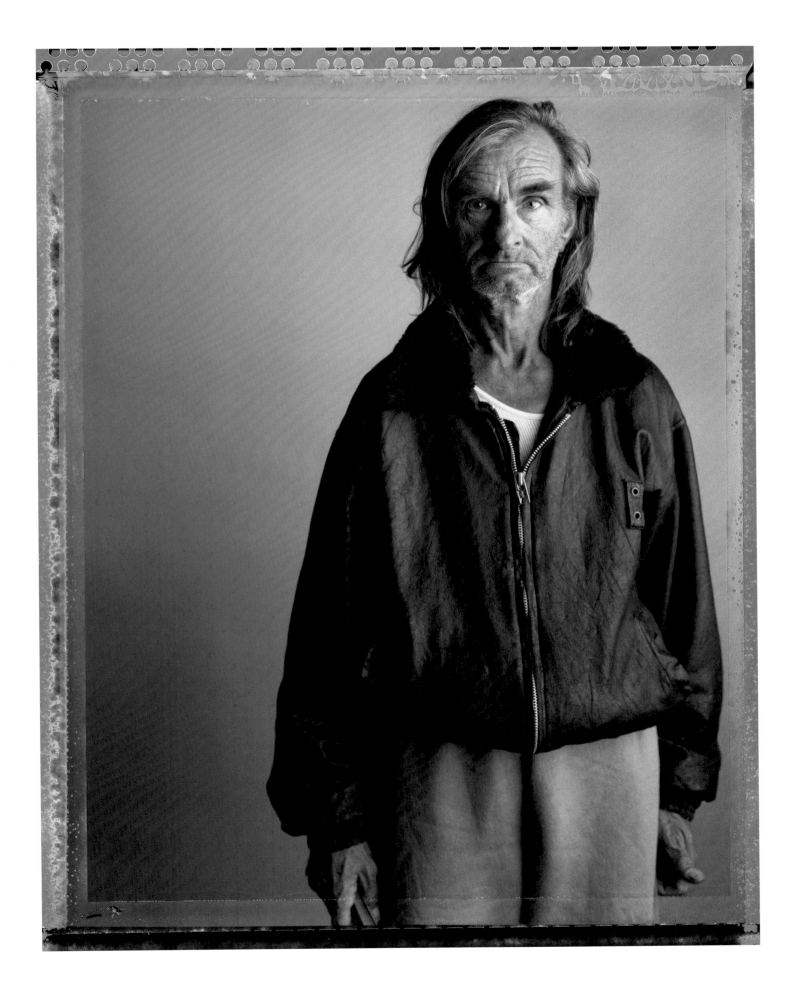

THIS BOOK WAS SUPPORTED IN PART
BY THE UNIVERSITY OF TEXAS PRESS
ADVISORY COUNCIL.

Requests for permission to reproduce material from this work should be sent to:

Permissions
University of Texas Press
P.O. Box 7819
Austin, TX 78713-7819
www.utexas.edu/utpress/about/bpermission.html

☉ The paper used in this book meets the minimum requirements of
ANSI/NISO Z39. 48-1992 (R1997) (Permanence of Paper).

Library of Congress Cataloging-in-Publication Data

O'Brien, Michael, 1950- Hard Ground / photographs by Michael O'Brien ;
poems by Tom Waits. — 1st ed.
p. cm. ISBN 978-0-292-72649-9 (cl. : alk. paper)

1. Homeless persons—United States. 2. Homeless persons—
United States—Pictorial works. I. Waits, Tom, 1949- II. Title.

HV 4505.O25 2011 362.50973—dc22
2010038521

Page 2 GARY FAURIES
Page 3 BRIAN LOHSE
Page 5 ROBERT SPICER

Book and jacket design by DJ Stout and Barrett Fry
Pentagram, Austin, Texas

FOR MY WIFE, ELIZABETH, AND OUR CHILDREN, JESSE, OWEN, AND SAM.

Thanks to Tom for your support, creativity, and belief in this project. Your poems brought this book to life. Nothing has meant more to me over the years than your and Kathleen's friendship.

I especially want to thank Dave Hamrick, U.T. Press Director, who believed in the photographs from the beginning. Your commitment, counsel, and friendship never wavered throughout the process. Without your help, this book would not be.

Thanks to DJ Stout and Barrett Fry at Pentagram for your intelligent, eloquent, and beautiful design. DJ, you have been my editorial partner and more importantly, my good friend, for years, beginning with our collaborations at *Texas Monthly*. Thanks again for making me look good.

Three gifted photographers encouraged me during this venture: John Loengard, Mary Ellen Mark, and Brian Lanker. You are my heroes.

Thanks to my old friends at the *Miami News* who helped shape me as a journalist: Don Wright, the late Charlie Trainor, the late John Keasler, Howard Kleinberg, and Paul Shea. Each of you, in your own way, taught a kid with a camera how to be a newspaperman.

Thanks to Alan Graham of Mobile Loaves & Fishes for helping me begin this project, and to the late Duane Severance for allowing me to attend his Tuesday night dinners and worship services. Your tireless work on behalf of the homeless has been a powerful inspiration.

Thanks to all the fine people at University of Texas Press—Joanna Hitchcock, Theresa May, Leslie Tingle, Nancy Bryan, and Ellen McKie—for your professionalism throughout the publication process.

Finally, a special thanks to Elizabeth O'Brien, Kathleen Brennan, Jace Graf, Angela Atwood, Bill Wittliff, Lynda Lanker, Roy Flukinger, Sean Perry, Julianne Deery, Mike Hicks, Jeff Stockton, Matt Lankes, Kara Payne, Dennis and Helen Darling, Joe Ely, and Bob Schiffer. Each of you supported me with grace along the way.

WHO WAS JOHN MADDEN?

BY MICHAEL O'BRIEN

It took a year to find my first job. It was 1973 and the country was in recession; like most businesses, newspapers weren't hiring. I had graduated from the University of Tennessee, Knoxville, with a major in philosophy. During college I worked for the student newspaper and had created a decent portfolio. Charlie Trainor, Sr., the chief photographer at the *Miami News*, saw my work and gave me a chance. He only had an opening for a darkroom technician, but I took the position. This turned into a photographer's job within weeks when another photographer unexpectedly left the paper. It was a dream come true: I was one of seven staff photojournalists. The *Miami News* shared a building with the larger city paper, the *Miami Herald*, and the huge structure sat on the mouth of Biscayne Bay, right by the MacArthur Causeway. It was an impressive, tropical setting, ringed by royal palms and within sight of the Port of Miami and the docked cruise ships. For the next six years, I did not think about anything except taking pictures for the *News*.

MIAMI 1975

Most every assignment began in the same way. I'd take the freight elevator down from the sixth-floor newsroom to the parking garage. I slung my cameras over my shoulder in an Orvis fishing bag, which I tossed into the front seat of my Chevrolet Impala, a company car that came with the job. When I started the ignition, the police scanner crackled, spitting out the dramas of the city, one by one—drownings, murder-suicides, traffic accidents, fires. If I heard a promising police call, I sped down the street steering the car with my knees, leaving my hands free to load my two Nikons with fresh rolls of film. Being there first meant you got the best picture, but you had to have loaded cameras. A couple of seconds made a big difference. I was competing against the big brass at the *Herald*, with a news photographer staff of twenty-five. I tried to anticipate what would happen—and where—in the city, so I'd be in the right place to get the picture. At the newspaper, you had to survive by your wits—or gut instinct. News photographers were measured by the pictures they got.

As I became conversant with my job, I established a routine. I'd take 12th Street to zip onto the expressway. If I didn't make all the lights, I'd get snagged by a red at NE 1st Avenue, right before the on-ramp. One day, stymied by the light, I glanced left out of my car window and saw an old man sitting on the drainpipe beneath the expressway. Miami had a large homeless population. But this man's face was like no other. Grizzled and burnt by the searing South Florida sun, the grit was baked deep into his skin. He had dark plaintive eyes that caught mine. I looked away; I didn't want

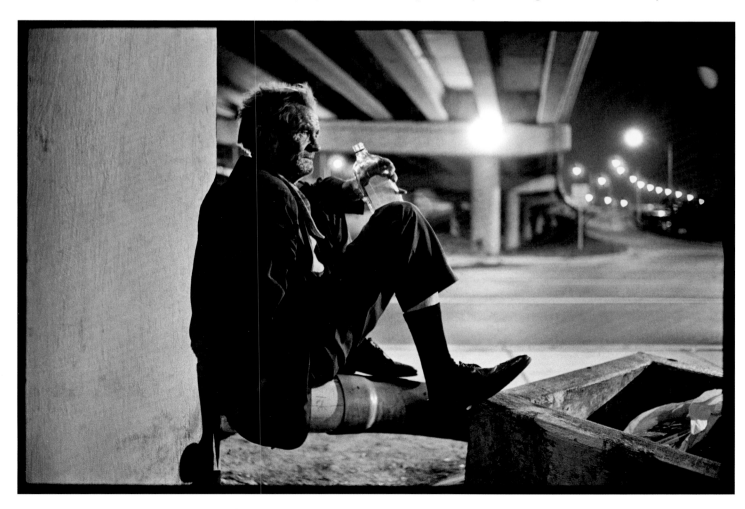

to be caught staring. But I was hooked; it was electric. His image was indelible, etched into my mind.

I became fixated with this man and wondered as I headed to each assignment if I'd see him there. Most times I would.

Who was he, where had he come from, did he have a family, where did he live, how old was he? All these questions. I was curious, but too timid to stop and approach him. I knew I should. I was a newspaperman. This man had to be a story.

Each time I passed him and didn't stop, the more conflicted and guilty I became. On one slow news day, I headed out of the *News* building as usual, planning to cruise downtown with hopes of finding some spot-news or a feature shot. I was about to get onto the expressway. But that day, for some reason, I had the courage to stop. I parked the car around the corner and approached him on foot. I left my cameras in the car. I didn't want to spook him.

I walked over ground under the viaduct strewn with empty bottles, litter, food debris. I said hello, introduced myself. He was okay; he didn't bite me. In fact, he was pretty talkative. I was surprised he seemed happy to have someone to listen to his stories. And he was a good storyteller. I was shy and a good listener. After about an hour, I told him I worked for the newspaper and asked if it would be okay to take some pictures of

him. I expected him to tell me "no thanks" or ignore my request, but instead he shrugged. I went back to my car and grabbed my cameras and took a few pictures. I wanted to begin before he changed his mind.

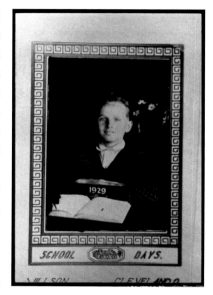

I found out his name was John Madden, born in Manchester, Georgia, fifty-seven years earlier. He lived on the streets in downtown Miami, didn't like staying at the rescue mission or the Salvation Army, and preferred to sleep out in the open air. He was a southerner, a born storyteller unhampered by facts. He would talk as long as I would listen. He had been married, had three daughters, divorced. I wanted to find out what happened—how he went from growing up in a small southern town to living underneath the underpass in downtown Miami.

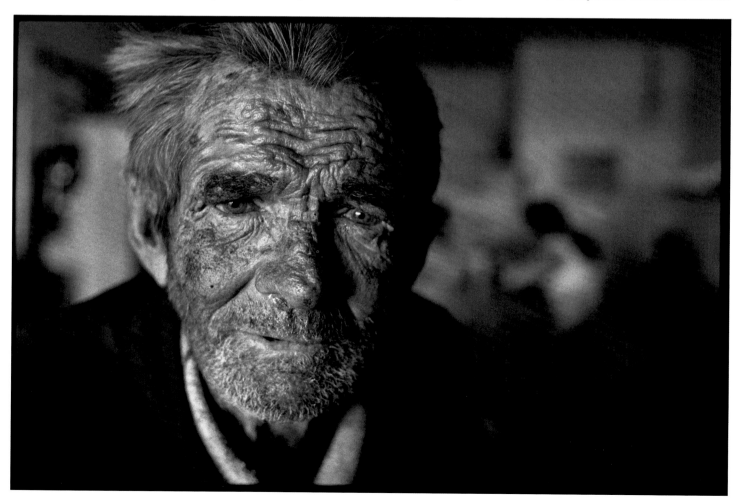

I started taking photographs—where he slept, where he ate, his friends, and his drinking. He drank all day; whenever he had enough money, he'd take off and buy a pint of cheap white port: MD 20/20. Rotgut. I followed with my camera.

We were an odd combination. I was twenty-five years old, and this was my first job out of college. I grew up in an unremarkable, middle-class neighborhood in Memphis, Tennessee. I didn't know what I wanted to do until I got my hands on a camera. It fit perfectly. I was shy, inward, and the camera became my connection to the world, something I could hide behind while safely observing.

John Madden was real, someone who was brave enough, tough enough that he didn't submit to life's conforming forces and instead made the world conform to him. I didn't see a broken man; instead, I saw an original, ragged, hard-living street person. He didn't need to fit in. My job was to tell Madden's story in a set of still pictures that were as compelling as his life. I was lucky he had granted me access. I was in a place I never dreamed I would be, following someone I never would have met had I not picked up a camera.

I didn't let on at the paper what I was doing. Newspapers were always hungry and I feared the editors would force an early publication on a slow news day when there was a hole to fill. My boss, chief photographer Charlie Trainor, knew what I was working on, but he was good at keeping things quiet.

Don Wright was my mentor at the paper. Don started at the *News* as a copyboy and then moved up to photographer, picture editor, and finally Pulitzer Prize–winning cartoonist. Don had noticed my pictures when I first started at the paper. Getting a compliment from Don—"O'Brien, helluva picture!"—made my day. He was at the paper every night battling his 4 a.m. deadline for the next day's cartoon; I'd wander back to his office late at night when most of the staff had gone for the day. He was never too busy to get up from his drawing board and look at my work-in-progress. He was intrigued with Madden. He critiqued the shots candidly, commending what was good and letting me know where I fell short, and what I was missing from my photographic story. He was helping me with the visual narrative, as he was helping me understand what it meant to be a newspaperman.

Over the next several months, between assignments and on my days off, I photographed John Madden. I followed him and took pictures of what he did. He stood in the food lines at the Brothers of Good Shepherd, got picked up by the police, sent to jail, dispatched to dry out at the Dade County Stockade. He drank with his buddies, Lord Byron and Queenie, but most of the time he sat on a drainage

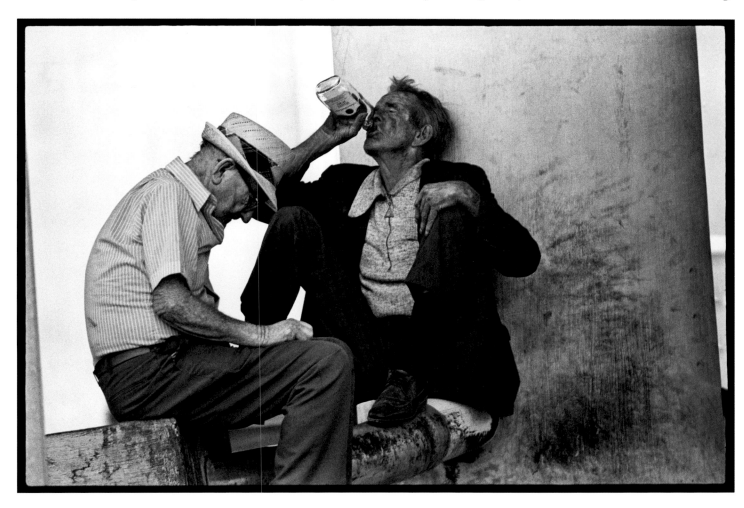

A postcard Madden mailed to his mother
while serving in the Army in Panama.
Madden was often sent to the Dade County
Stockade after being arrested for public
intoxication. (Facing page) Back at his corner,
he lies unconscious underneath the expressway.

pipe underneath the expressway at 12th Street and NE 1st Avenue.

I don't know when Madden and I became friends. He began to seem happy to see me when I came around. When I visited and photographed him in the stockade, I'd bring him a few packs of cigarettes and tell him his corner looked kind of lonely without him sitting there waving to passing motorists. I never once saw Madden panhandle or ask for anything. Passing cars would see him and offer him things—clothes, food, and spare change—but he never begged.

It was May and I hadn't seen Madden for a few days, I called the usual places—the jail, the stockade—but he wasn't around. I drove over to his corner and talked to some of his drinking buddies, but no one had seen him. I got worried. I checked the public hospital . . . no luck; and then I remembered that he had been in the Army. I called the VA hospital and was told that John Madden had died the day before.

It was like someone had slugged me in the gut. I hadn't realized it, but Madden had become a friend, someone I looked forward to seeing at least a couple of times a week. I never figured he could die. In my eyes, Madden was larger than life.

The paper decided to send me to the funeral with John Keasler, a seasoned columnist for the paper. Keasler was a gifted writer and a veteran newspaperman. No journalism school for Keasler; he was from the old school—he'd only made it through tenth grade. He never

met Madden, but together we went to Manchester, Georgia, and met Madden's family.

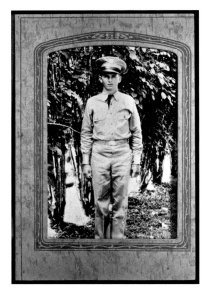

He had four lovely sisters. We found out that Madden had married and had three daughters. His sisters called him "Bud Lee." He was a high school track star who aspired to be a lawyer. I photographed his funeral and copied photographs from the family album: a school portrait when he was eleven, a portrait postcard from his time in the Army in Panama he sent home to his mother, and a photograph with one of his daughters.

When we returned to Miami from the funeral, the newspaper devoted three pages to the story and photographs.

MIAMI 2008

Fast-forward. I had just finished working for a week on assign-

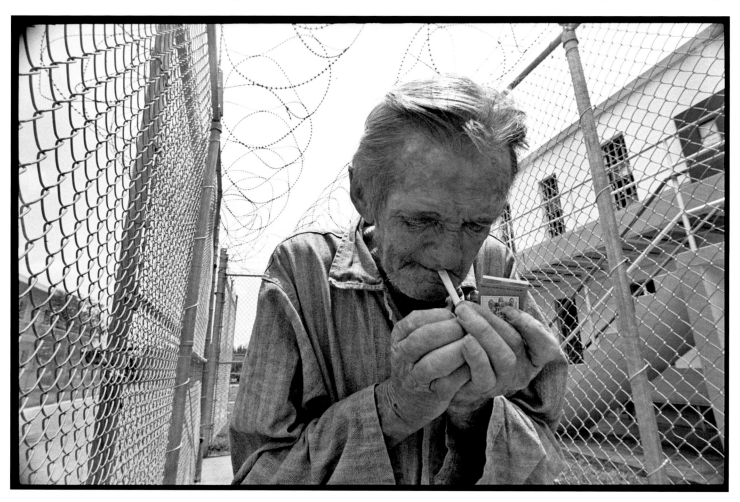

listened and wrote down what they told me. I was intrigued not only with what they had to say but also how they said it. The quote I can never forget is that of Stephen Blair, a fifty-three-year-old man originally from Venice, California.

I talk to my mother every once and awhile. She lives in Fort Worth, but I haven't seen her in twenty years. I go to a pay telephone every other day at 5 p.m. If the phone doesn't ring in five minutes, I know Mother is not going to call. But she calls most of the time. I ask her if she wants me to come home and take care of her, but she says she is okay. My mother has a loving heart.

I flashed back to Madden and remembered the photograph of him as a soldier that he had sent to his mother from Panama. I wondered if Madden kept up with his mother back in Georgia when he hit rough times and became homeless in Miami. Or did he just lose touch in his alcoholic haze? Did Madden call and check on his mom like Stephen Blair?

When I photographed John Madden in 1975, the homeless on the streets and in the food lines were primarily men in their forties and fifties. Today, it is different. The face of homelessness has changed. Instead of a mostly adult male population, today there are young and old, women and children, even families.

As I have shown these images, some have asked me if it was difficult to convince the subjects to have their pictures made. It wasn't. It is one of life's ironies that those who have the least are often the most generous.

"Taking a photograph" is a common expression, and indeed, the subject is giving something away to the photographer. But there is reciprocity between photographer and subject, and in this case, each subject received something tangible—a print that bore testament to a life. It is a safe encounter and it is a relationship, however brief.

The photography took three years. Polaroid went bankrupt, and my film was no longer being made. It seemed like a good time to end.

I felt a kinship with the people I was photographing. True, I have a home, a wife, and three children. I wasn't close to living on the street. But I was uprooted by the industry's change; I, too, was unsettled, floundering, often unemployed, trying to find a way to regain my balance and place. This project, and these subjects, gave me back my anchor.

Michael O'Brien

June 7, 2010
Austin, Texas

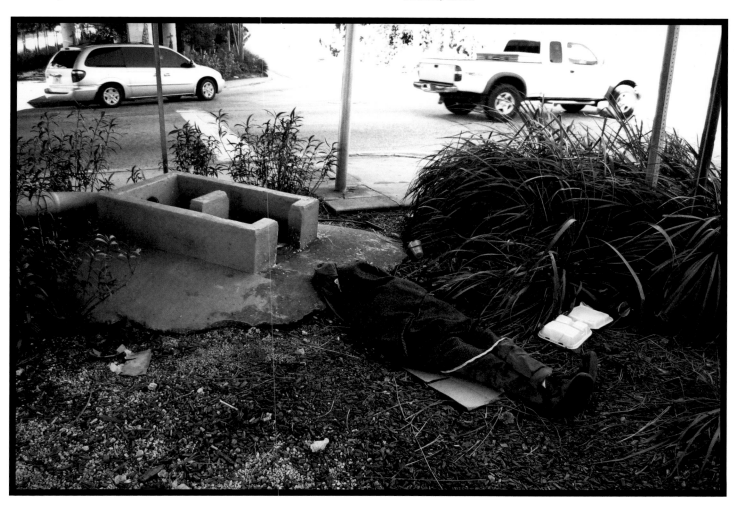

THE PLATES

OSCAR PALACIOS

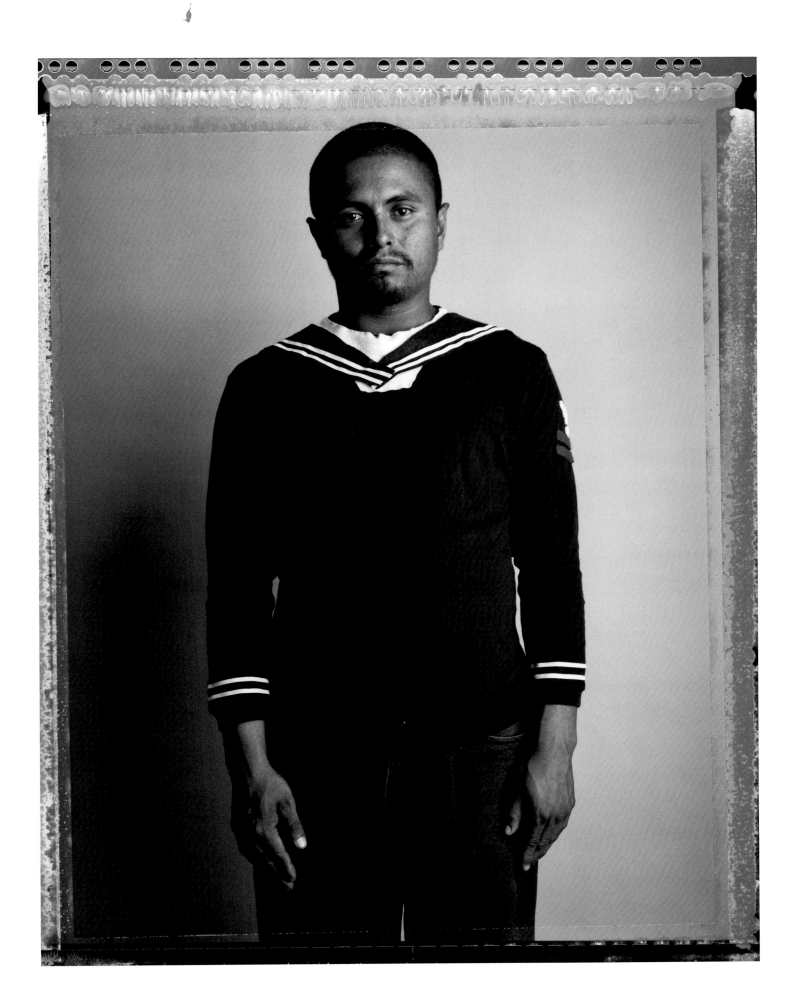

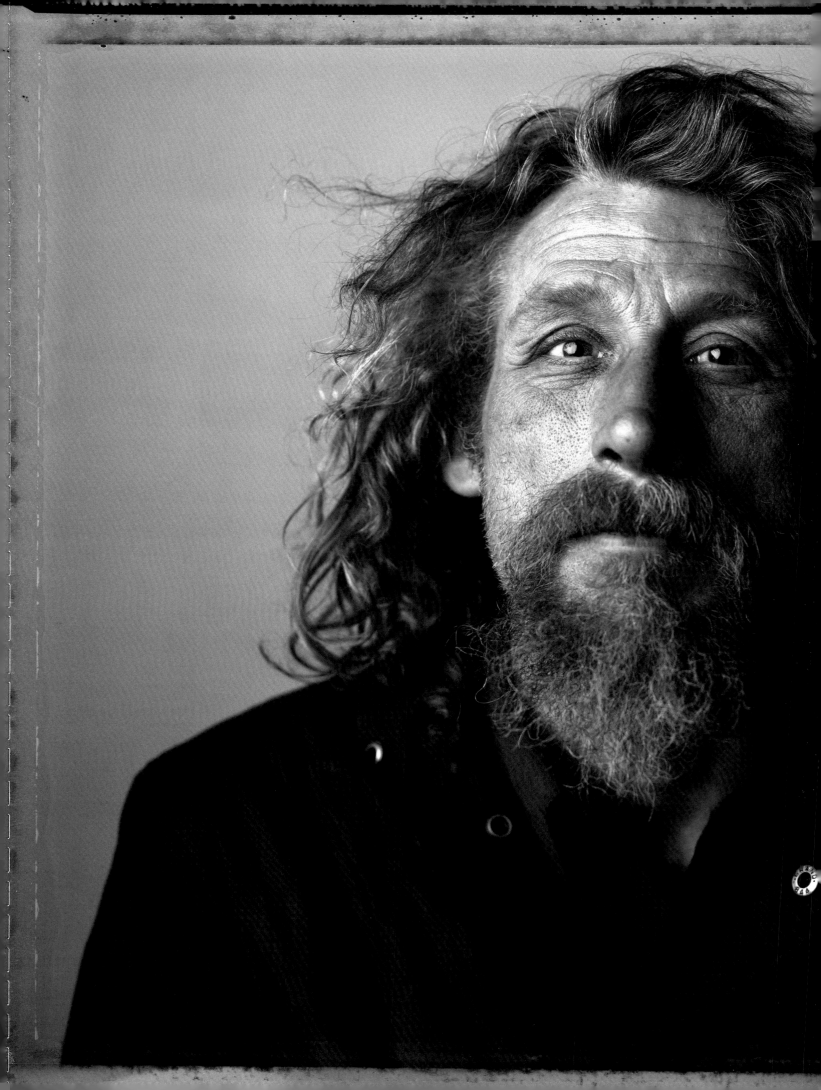

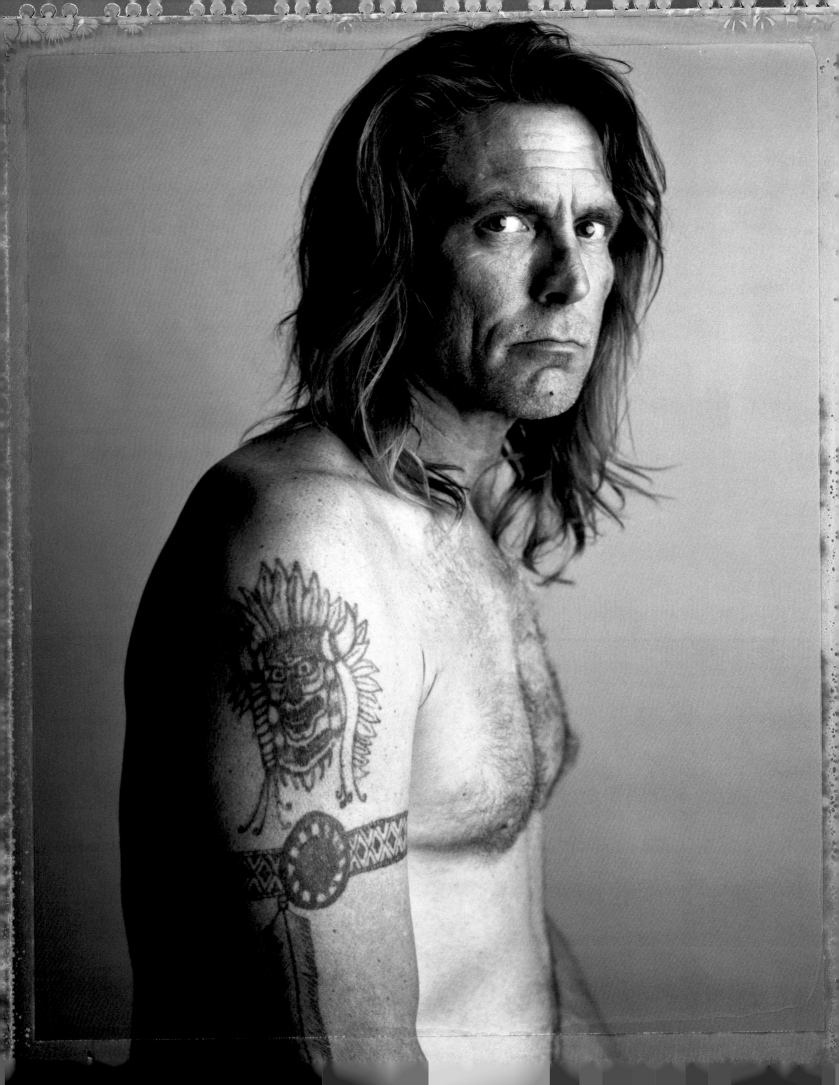

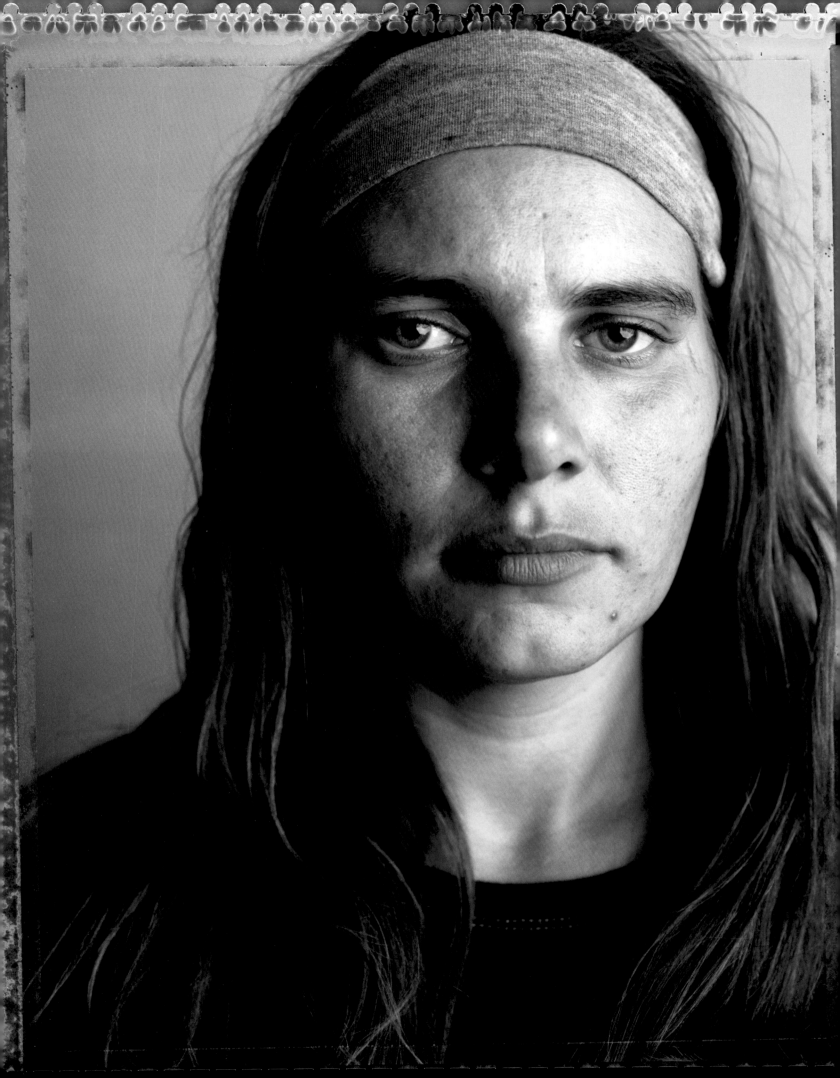

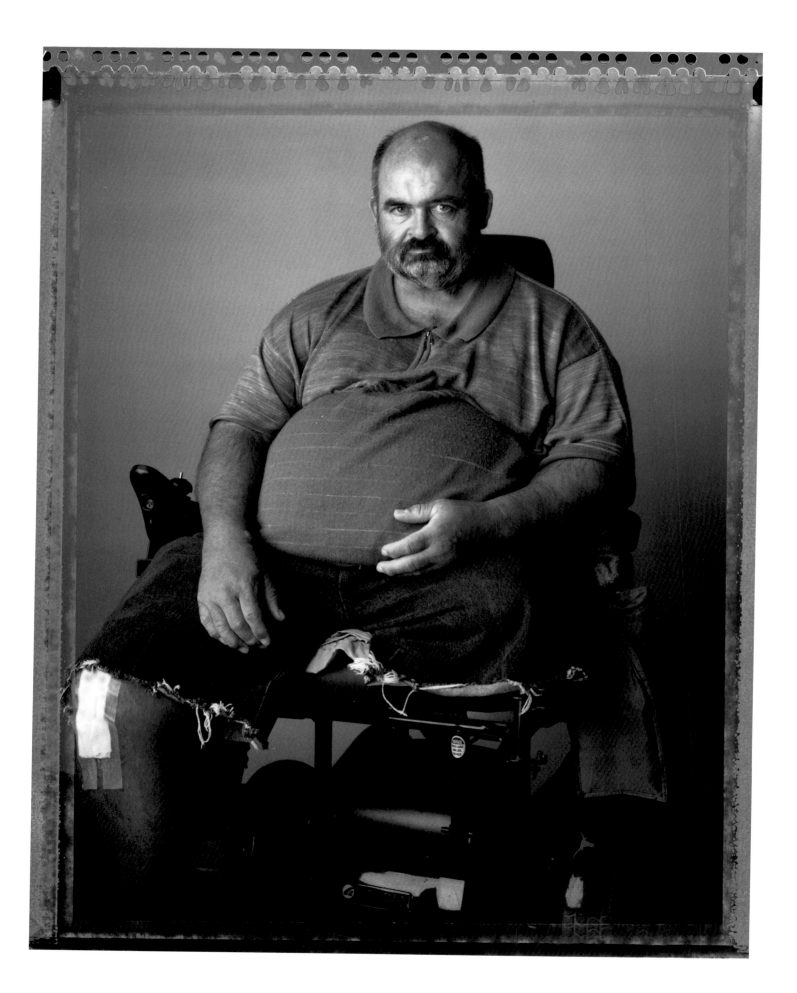

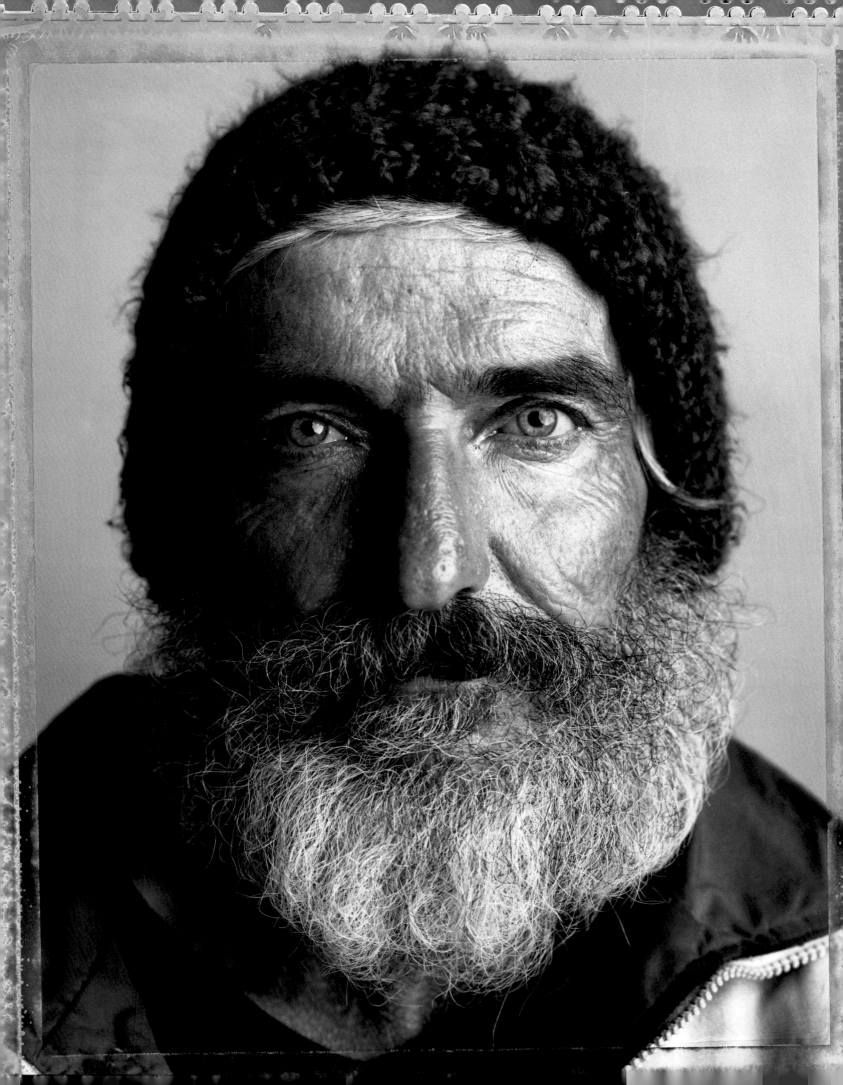

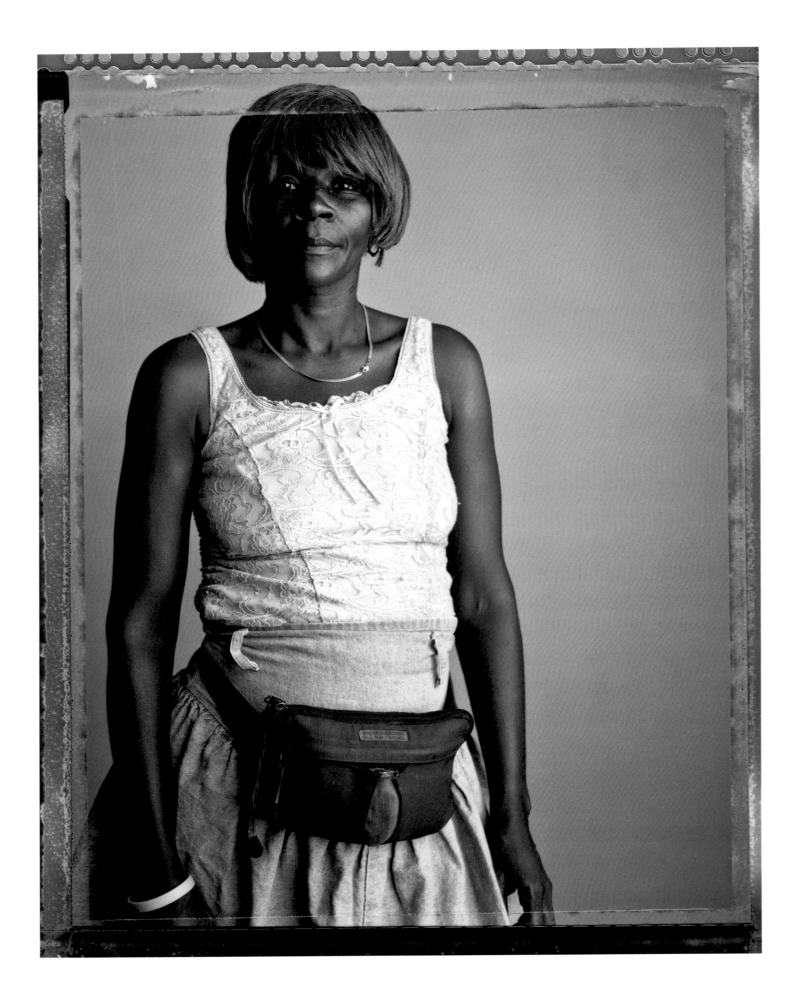

Seeds

I am a seed that fell
Upon the hard ground
The hard ground
The hard ground
I am a seed that fell
Upon the ground
I am a seed that fell
Upon the ground

I am a leaf that fell
From an oak tree
An oak tree
From an old oak tree
I am a leaf that fell
From an oak tree
I am a leaf that fell
From a tree

I am a stone that is rolling
On a rough road
On a rough road
On a rough road
I am a stone that is rolling
On a rough road
I am a stone that is rolling
On the road

Grit

Can I get up off the mat
Like a wrestler that has
Been beaten, beaten
Can I get up and come
Roaring back?

Cards

I guess some of us just
Get the old maid.

Nothing's Fair

Did I do it all backwards
Did I do it all wrong
Can I pull myself up by the
Boot straps of this song
Was I cursed and
It is over
Then how long
How long
Nothing is fair in this world
Nothing is fair
When I was born
My folks wept at my beauty
I was the package that all
Their good luck came in
I was bright and shining, magnetic
And flaming
Am I just something that got eaten
By the gods
Am I only just the bag
That it came in
My parents were good people
Shirley and Raymond
They prayed for a child
Just like me
They prayed for a child
Just like me
Sometimes I wonder if there is
Another life inside of this one
I was supposed to live
I've got to go now
See the train is pulling
Out of the yard
The train is pulling
Out of the yard

Did I Or Didn't I

Did I have it once and
Lose it lose it
Or did I look it in the eye
And choose it
Choose it

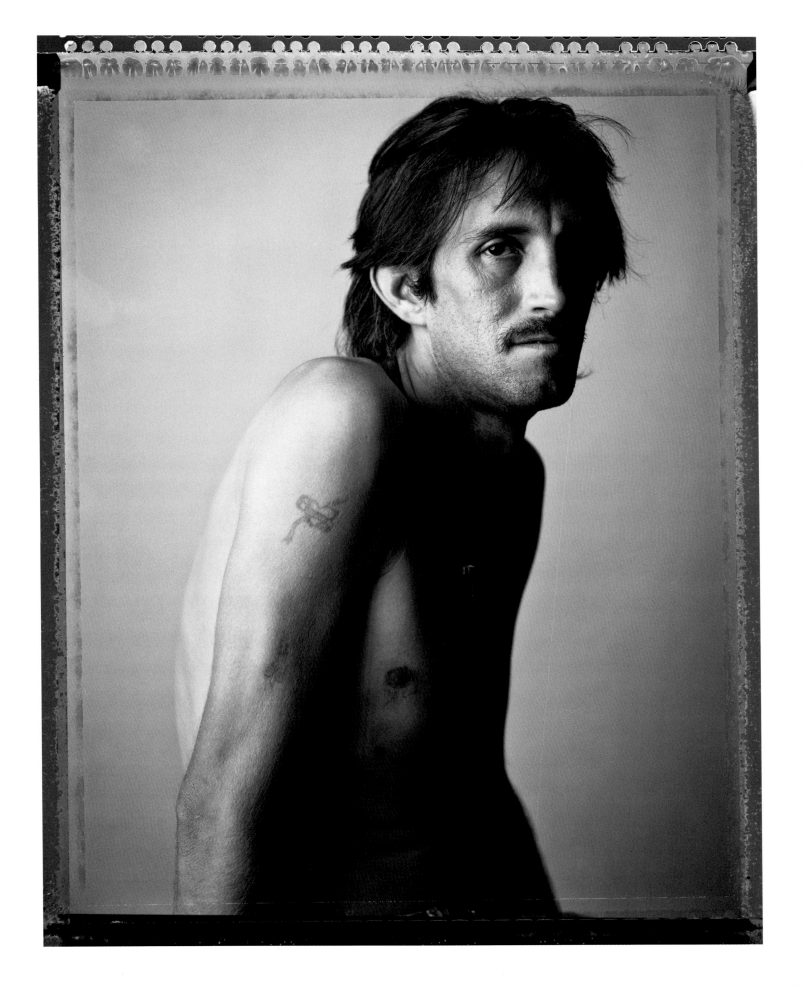

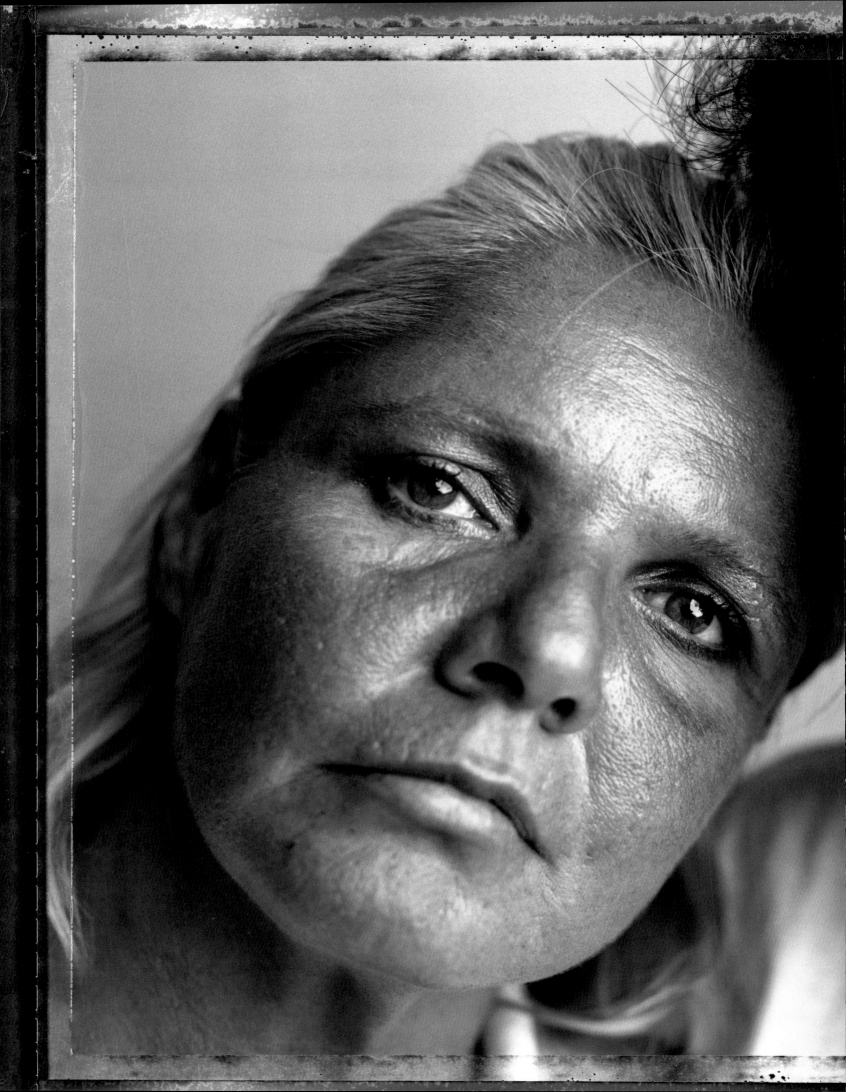

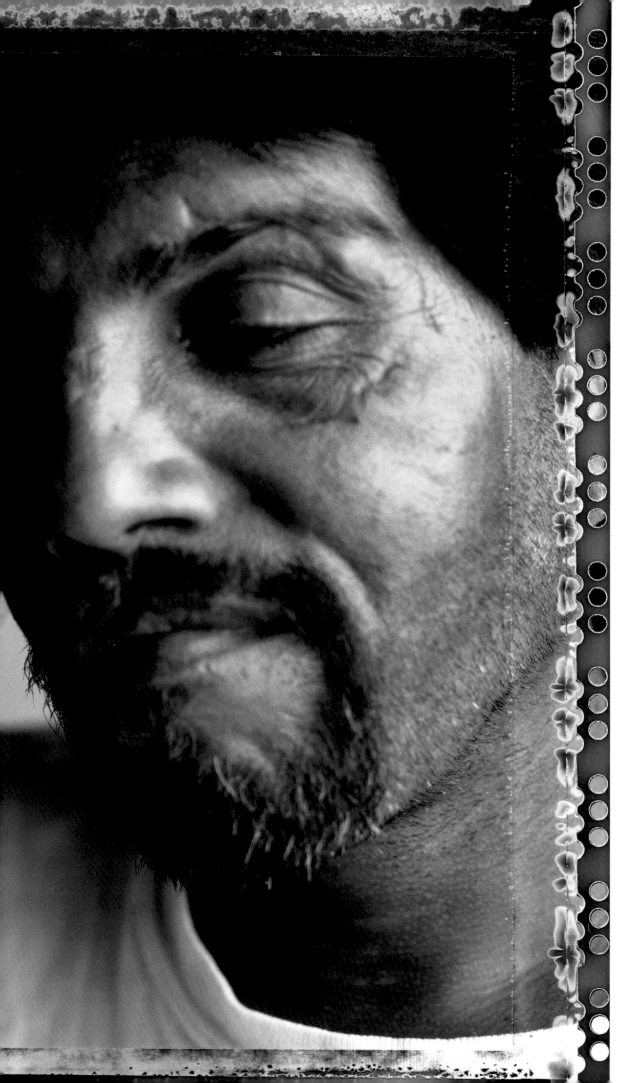

JOANN HERNANDEZ AND DAVID CABALLERO

MICHELLE ESPINOZA

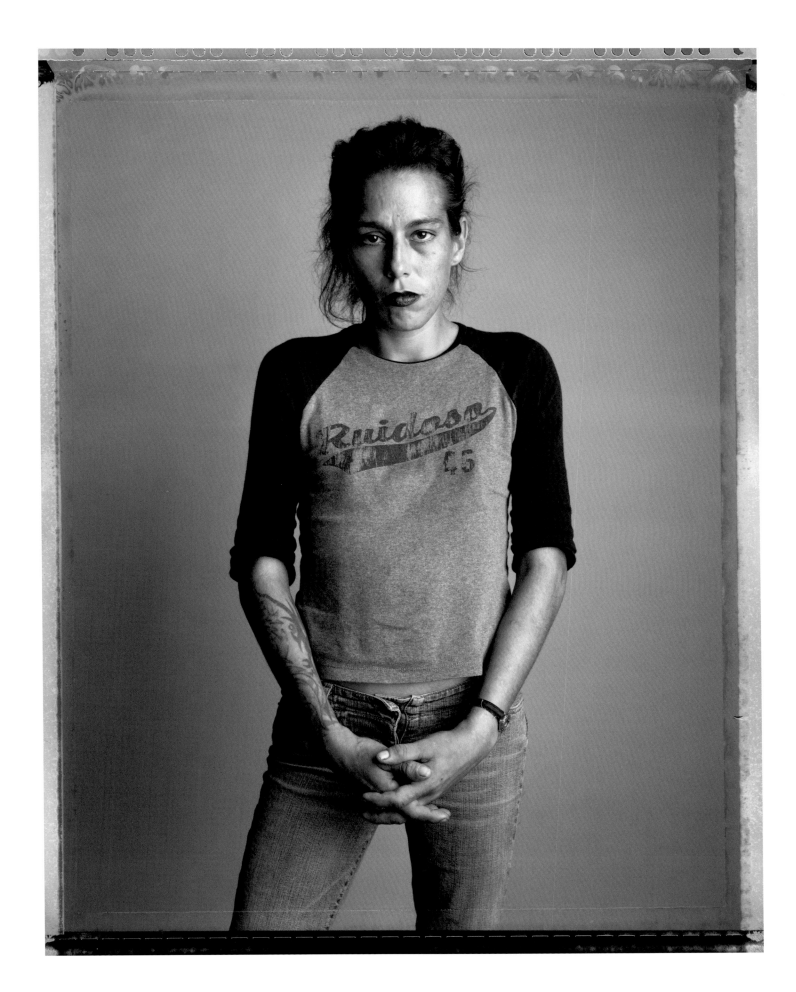

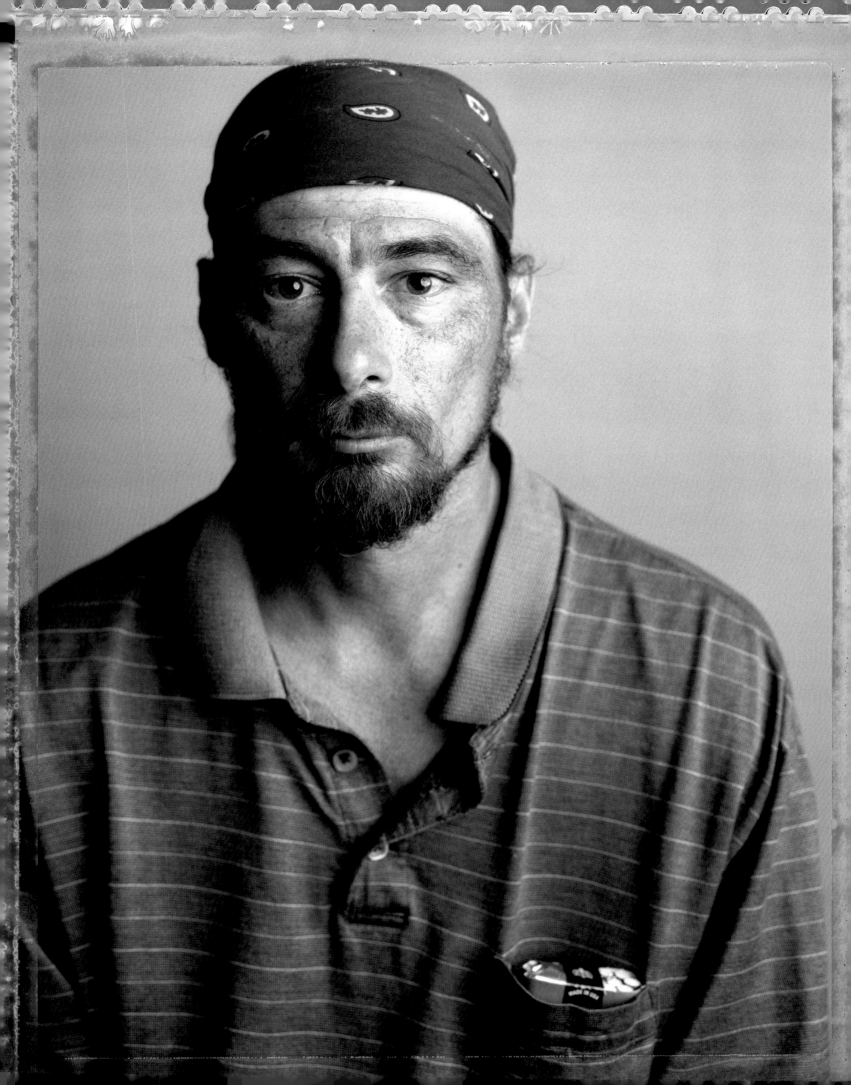

MICHAEL SCHRAMM

PAUL RANCE >

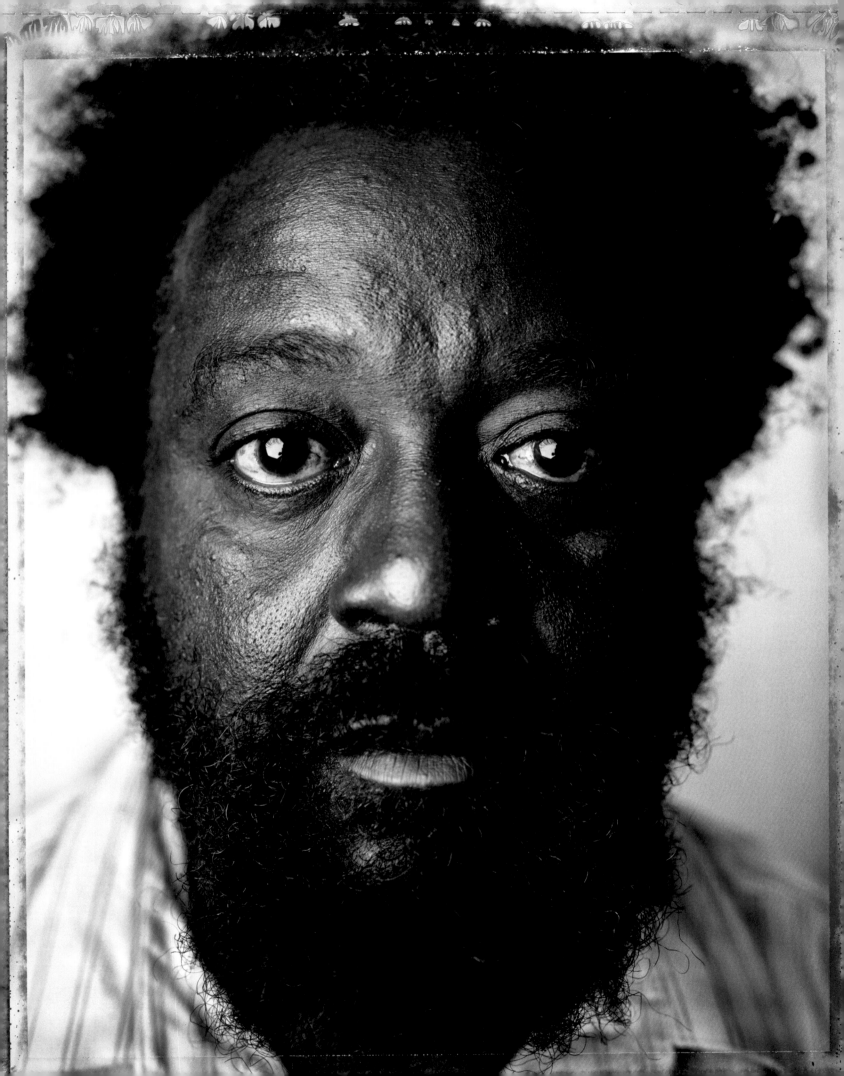

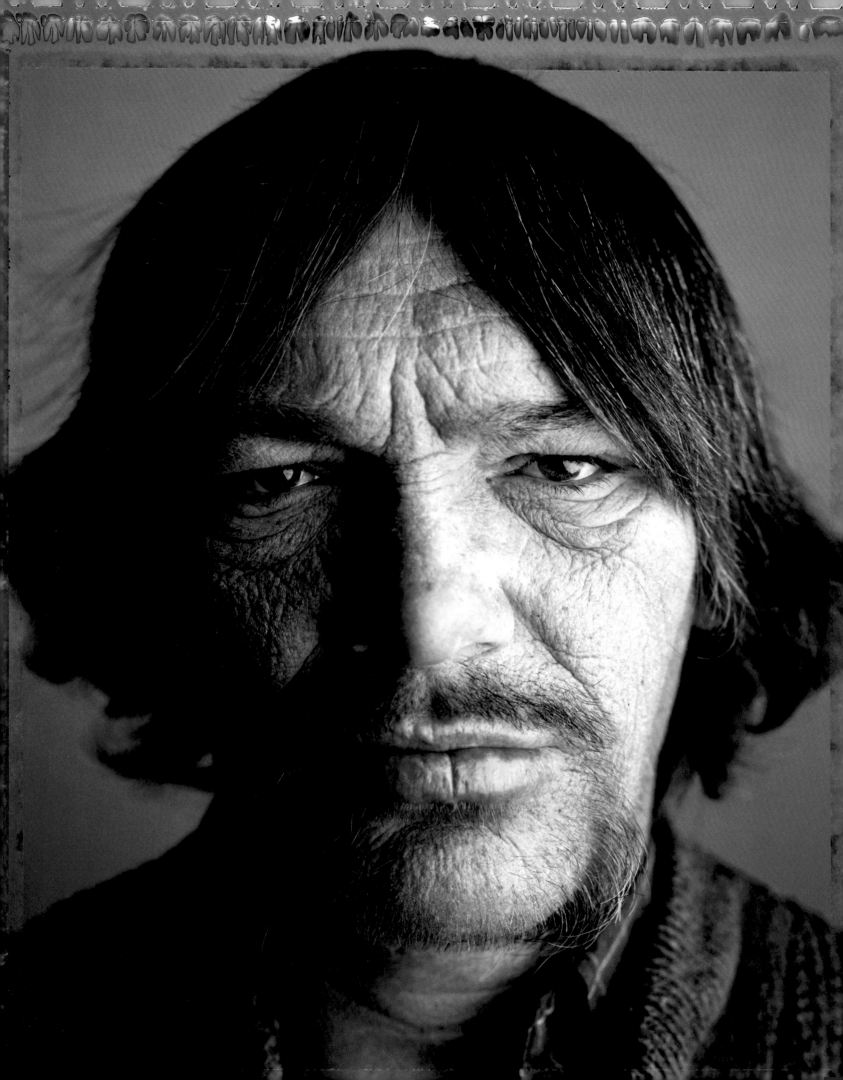

MICHAEL MAYES

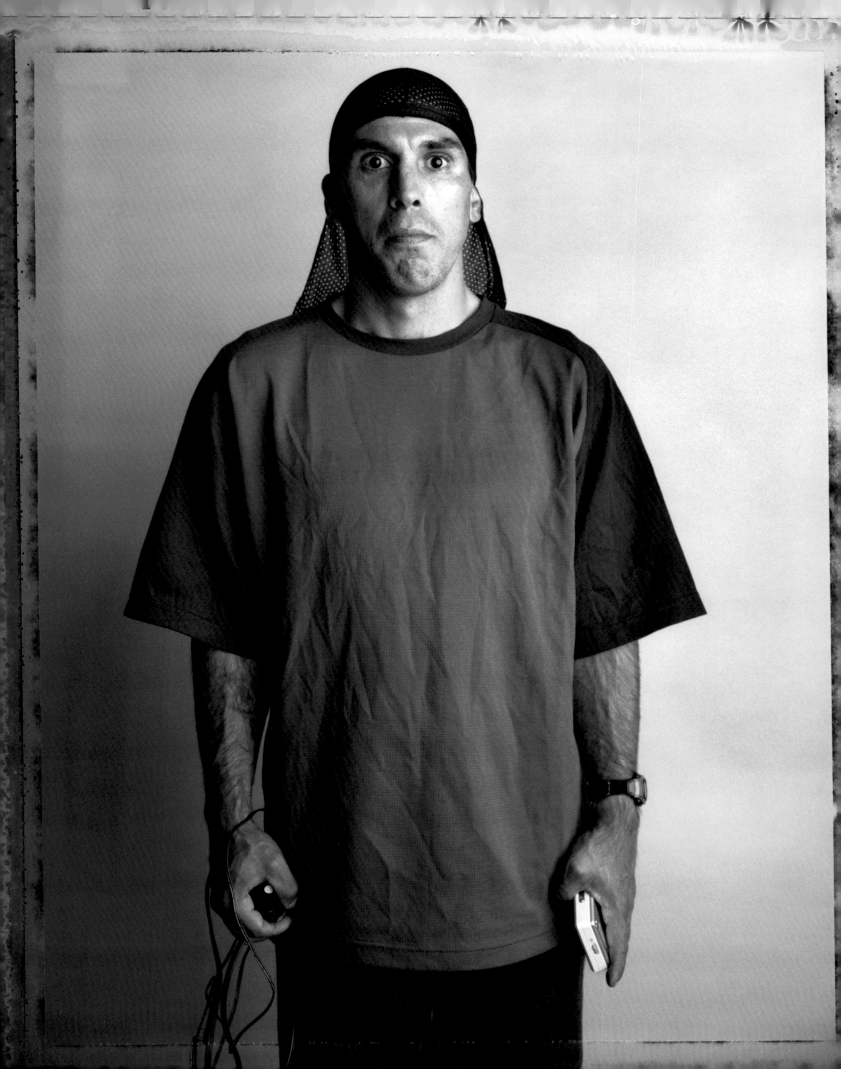

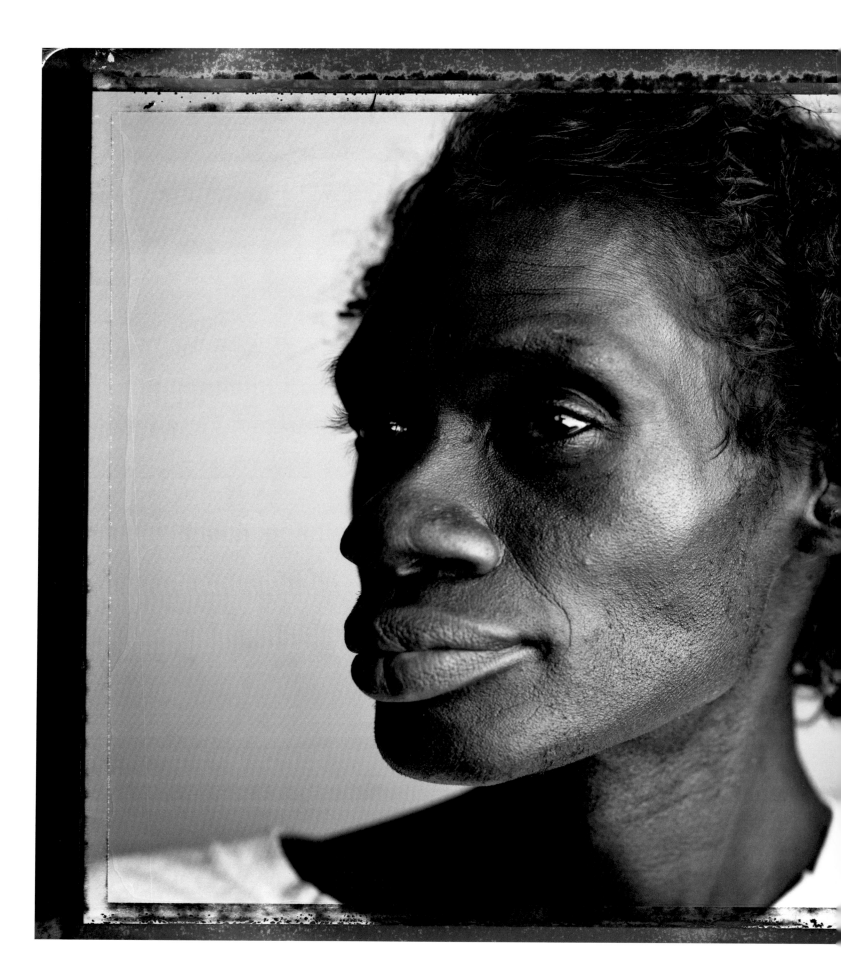

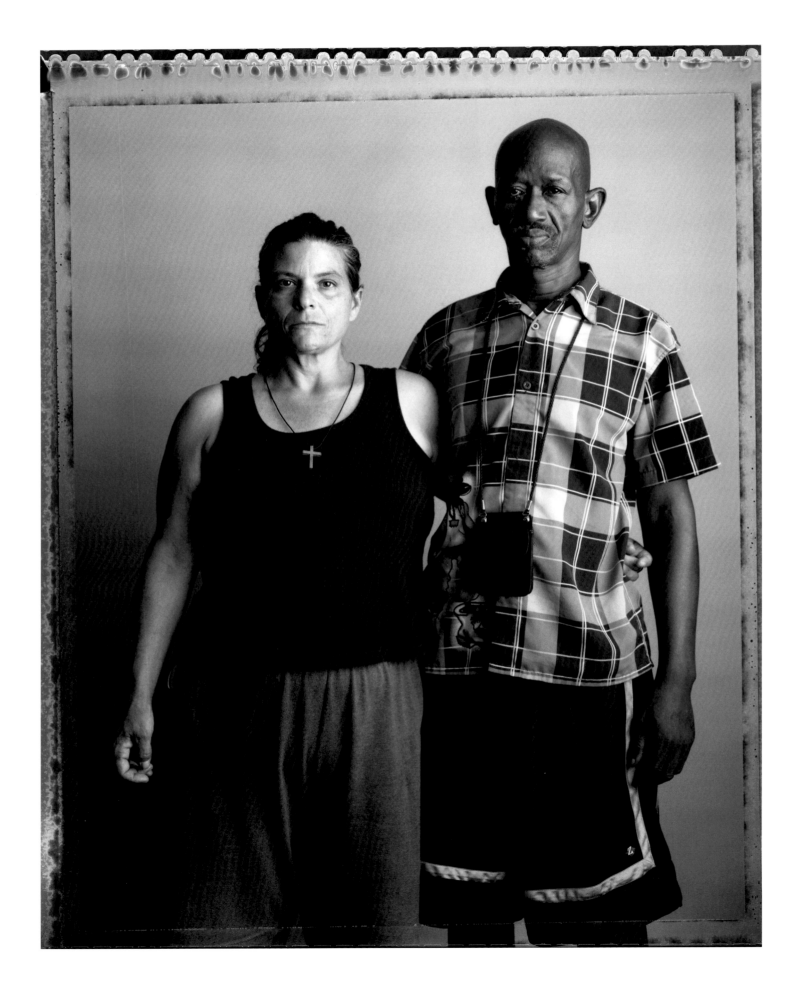

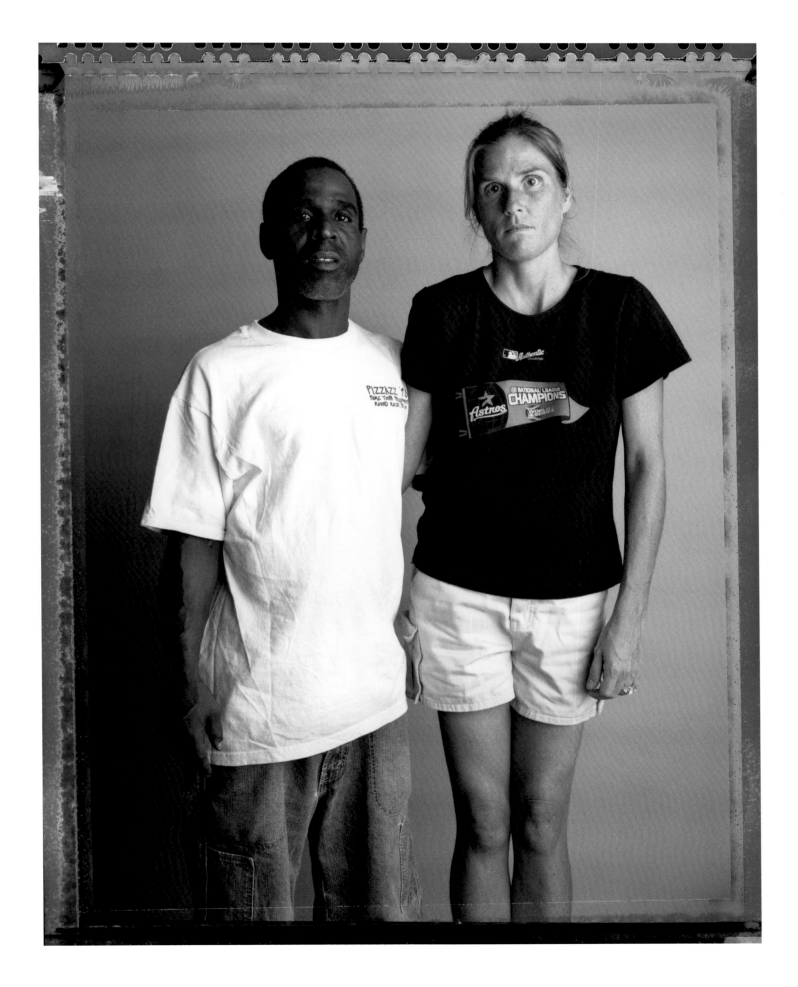

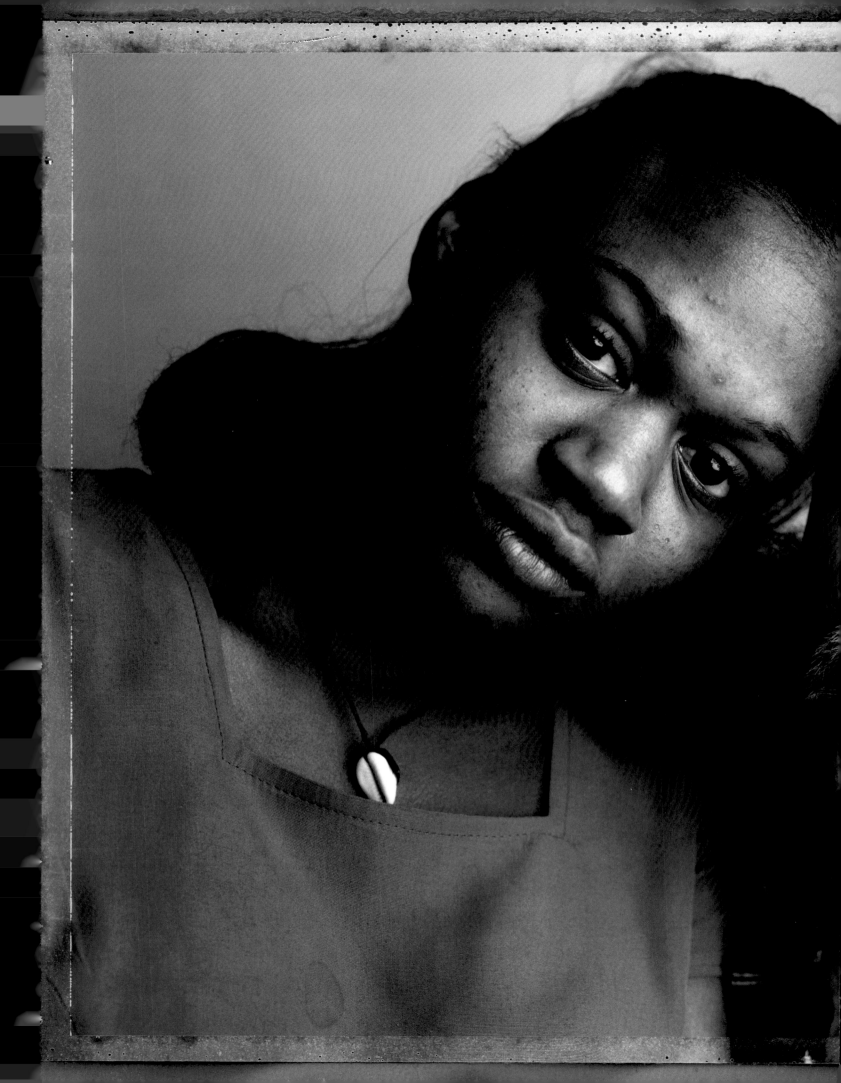

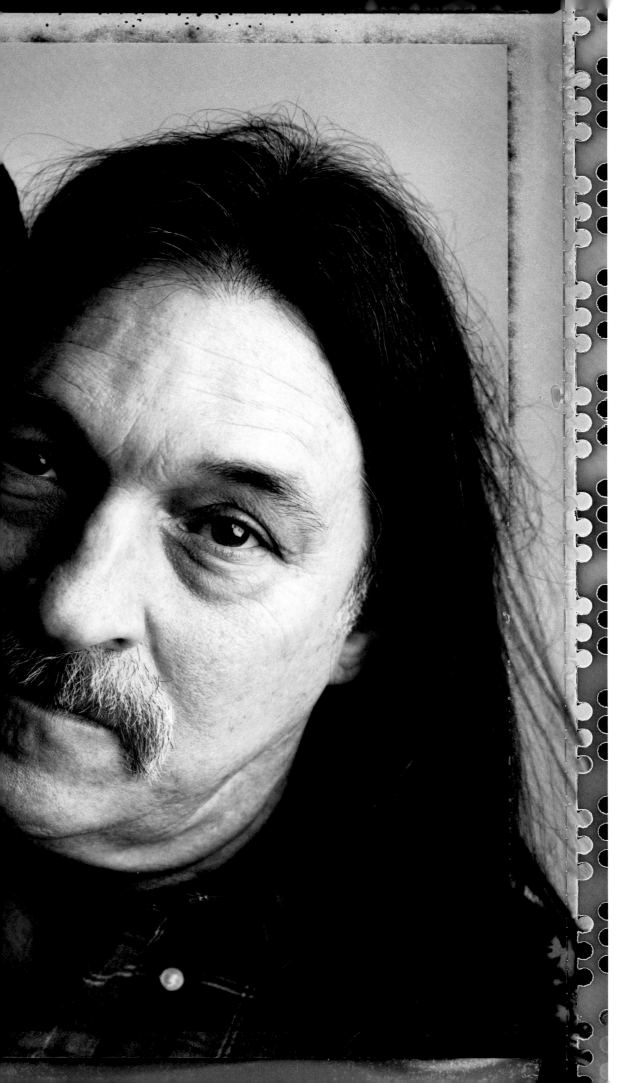

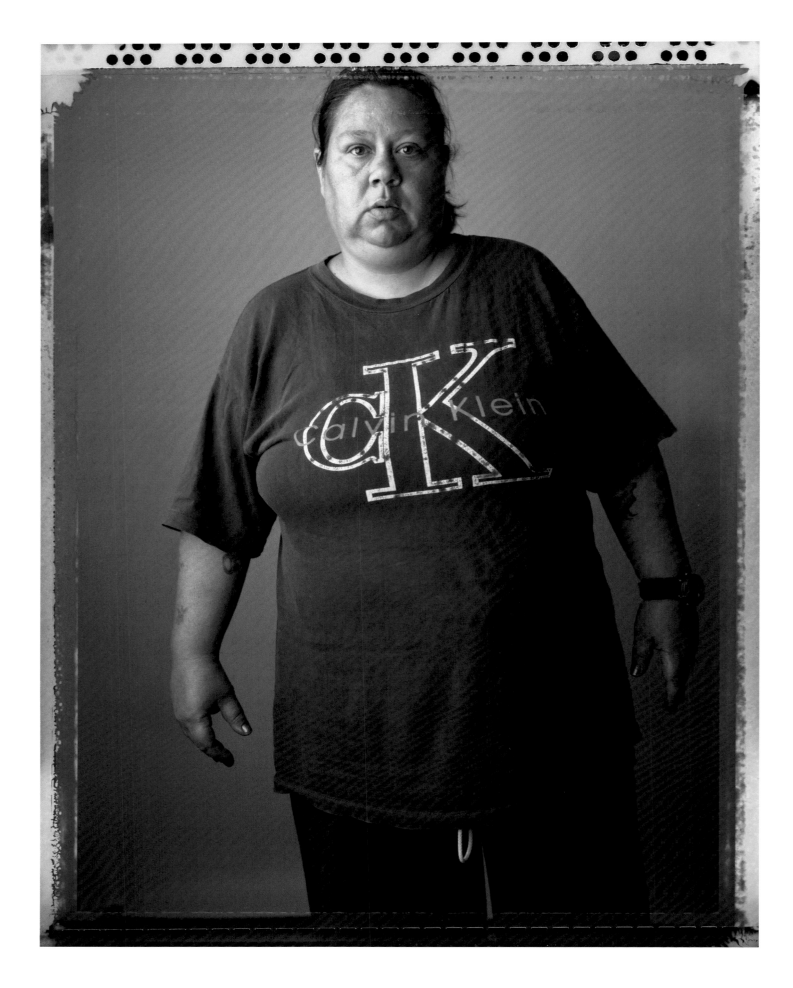

DAWN JOHNVIN

TERESA WAGNER

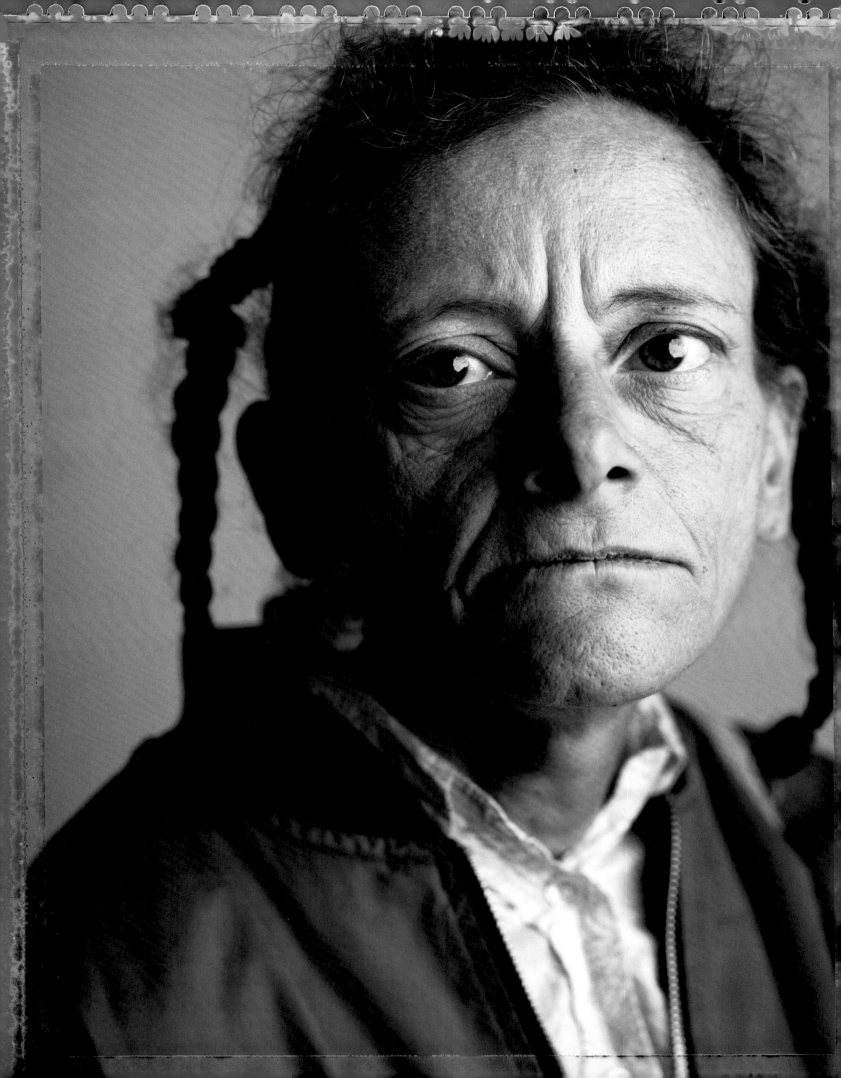

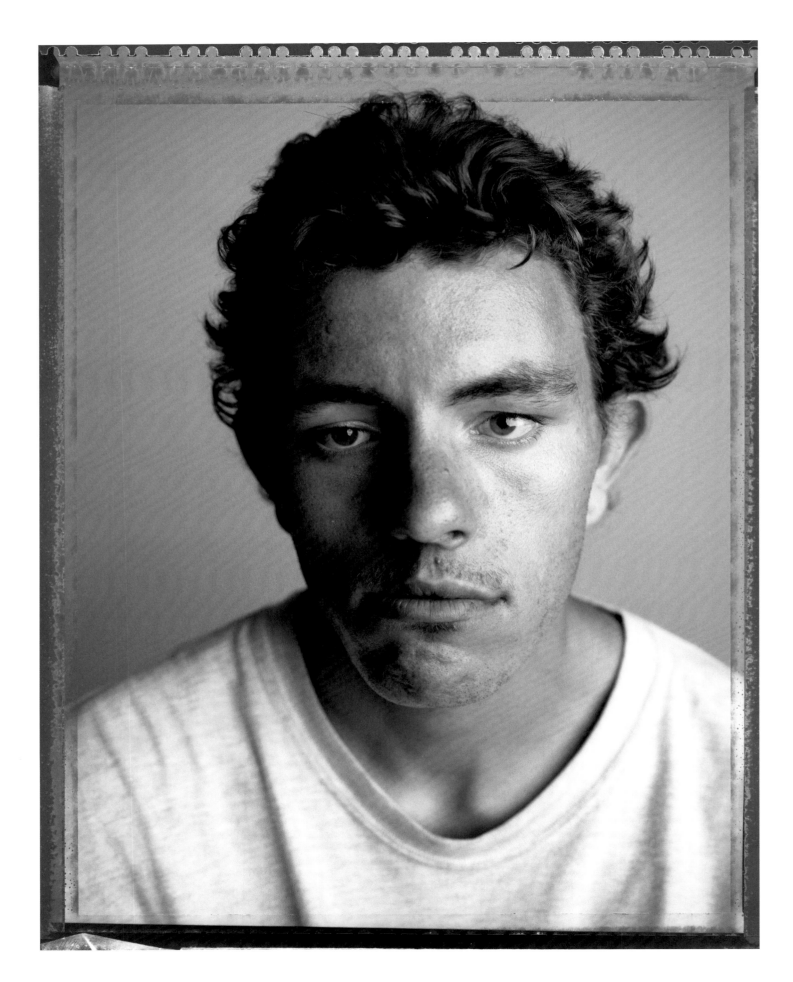

JAMES MORGAN

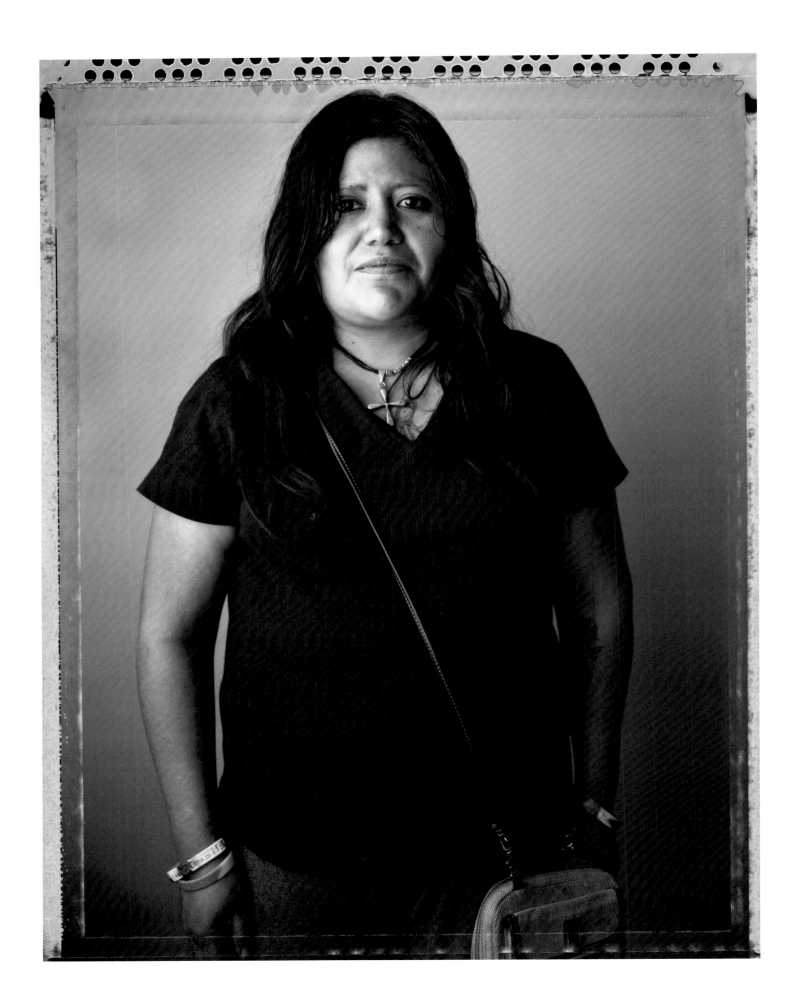

Down There

Down here oh Lord
Beneath the stairs
Down here oh Lord
There is a prayer
Way down underneath
All of these layers boys
Ally ally oxen free
Come find me Lord
Come find me

The Brass Ring

Trip
Foul up
Fall short
Blunder
Disappoint
Get it wrong
Stumble
Miss
Mess up
Wrong tree
Sinning
Blooper
Boner
Botch
Blunder
Winning

Geography

I held her little cheeks
And then I kissed em
I kissed em
Now I am scared and alone
And I miss em
I miss em
Maybe things will be
Different in Chicago

House

Roof
Porch
Siding
Eaves
Yard
Window
Doors
Ceiling
Floor
Kitchen broom
Living room
Counter
Screen
Sweet
Dream

Tell Me

I prayed when I was thirsty
And god sent the rain
I found berries by the
Side of the road
Tell me who does
God pray to anyway
It must be a lonely job
It must be a lonely job

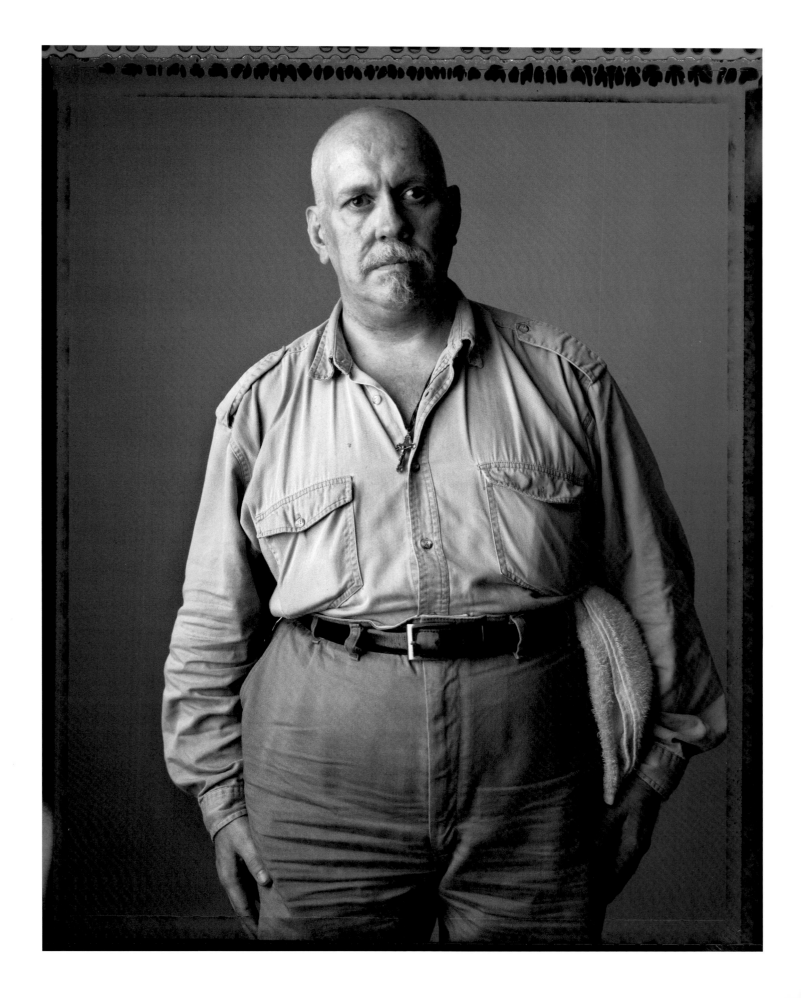

JUDITH MARIE CARREON

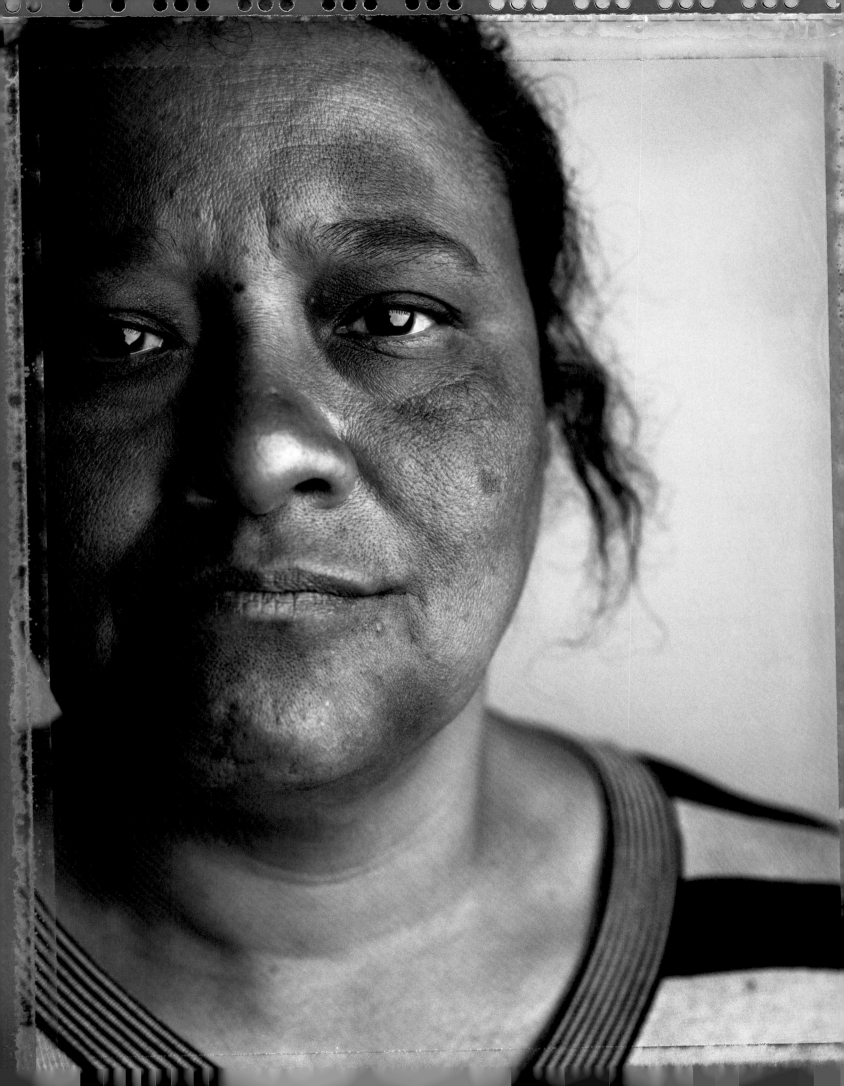

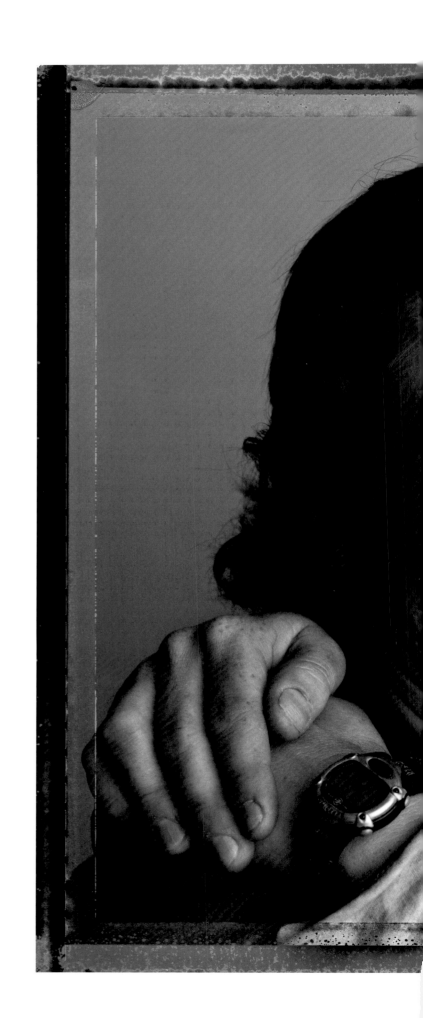

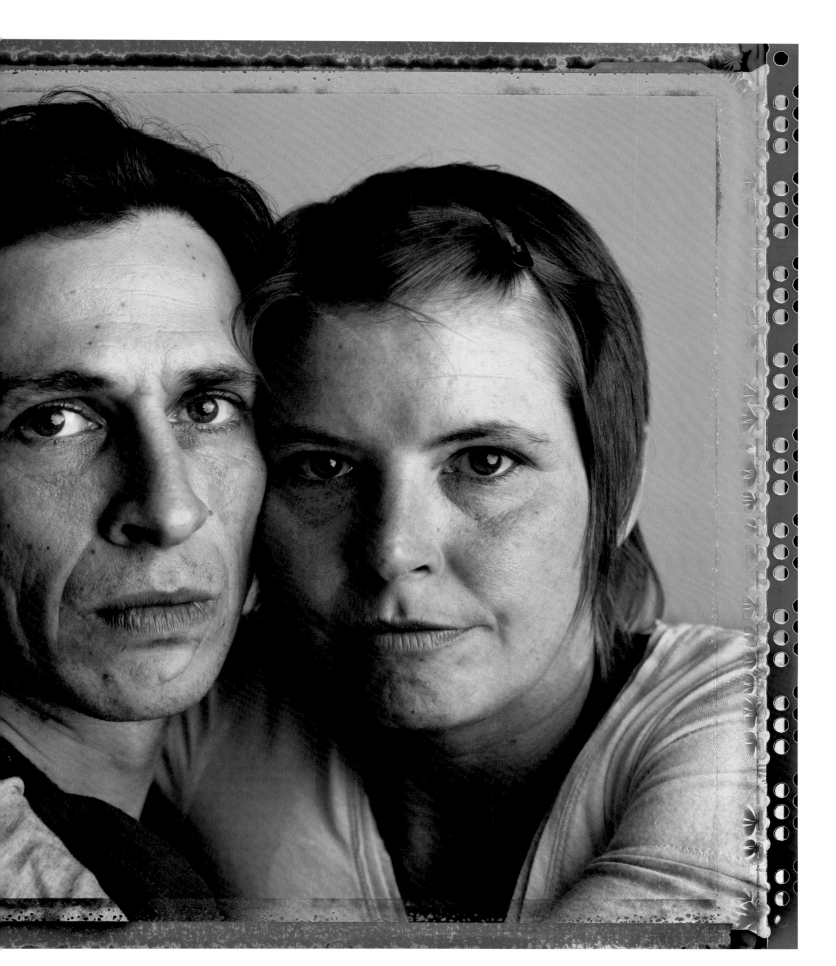

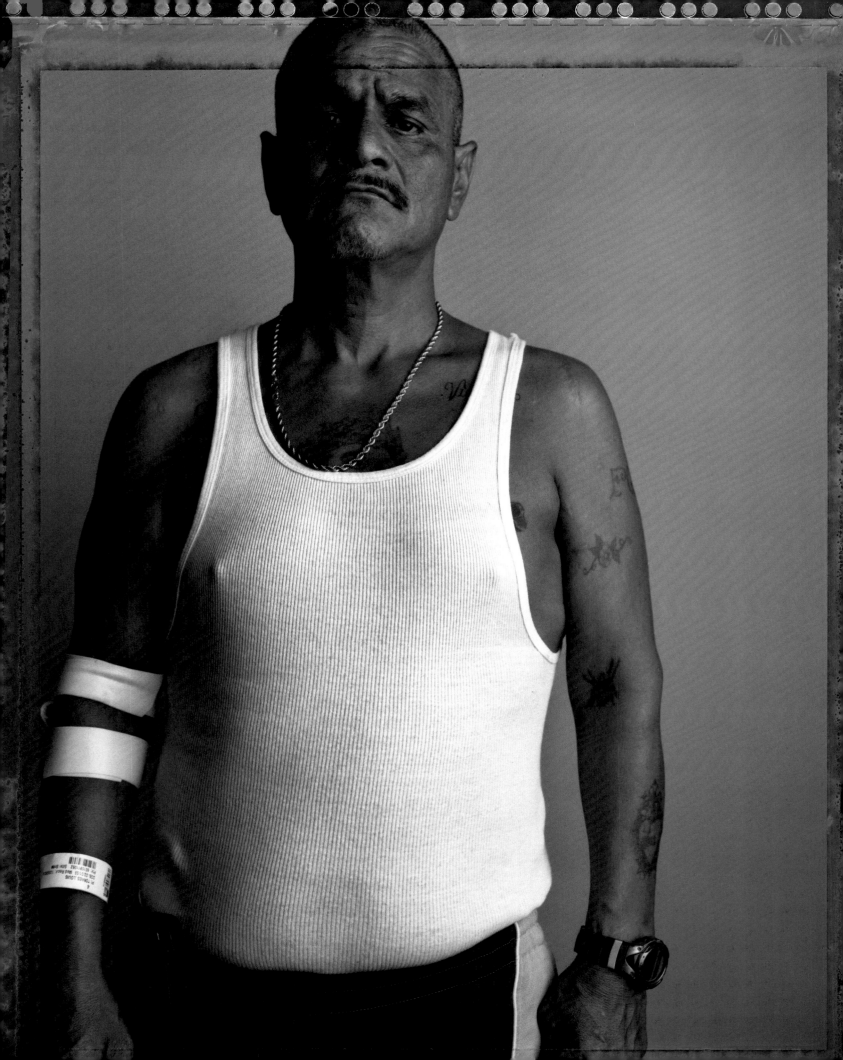

LOUIS TORRES

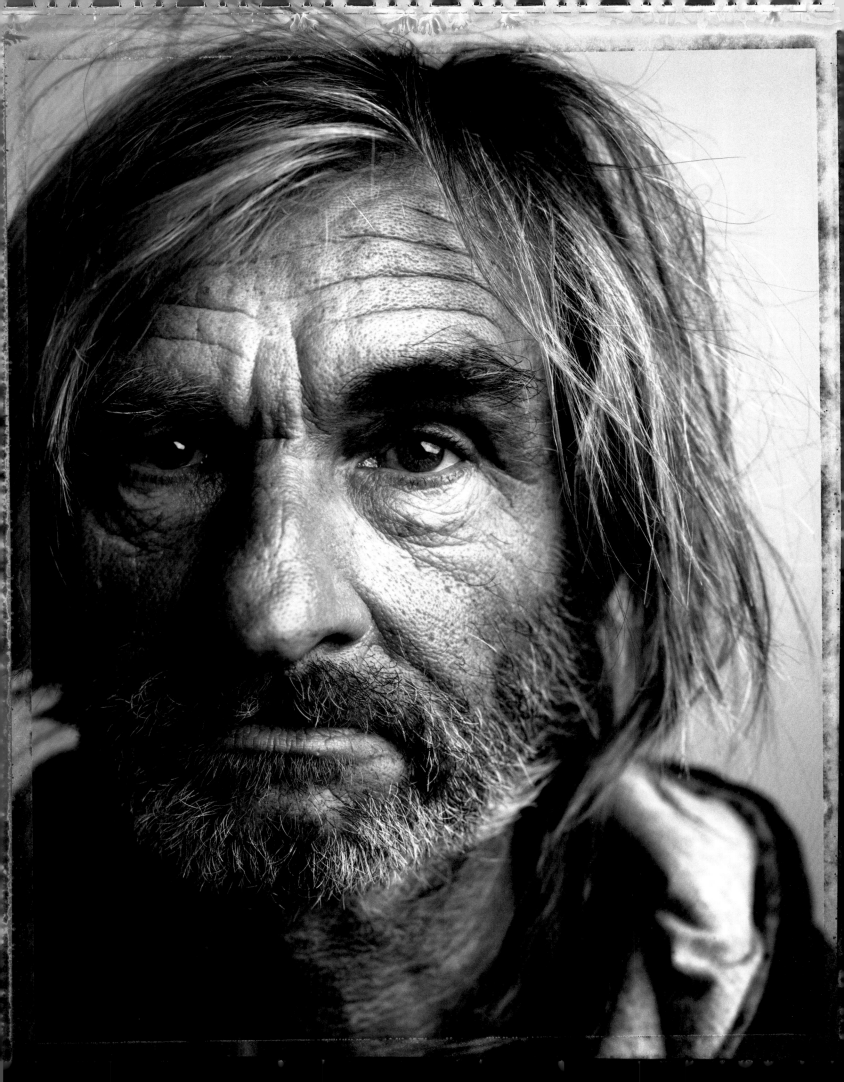

LAURA TANIER

RICHARD LEWIS III AND RICHARD LEWIS, JR.

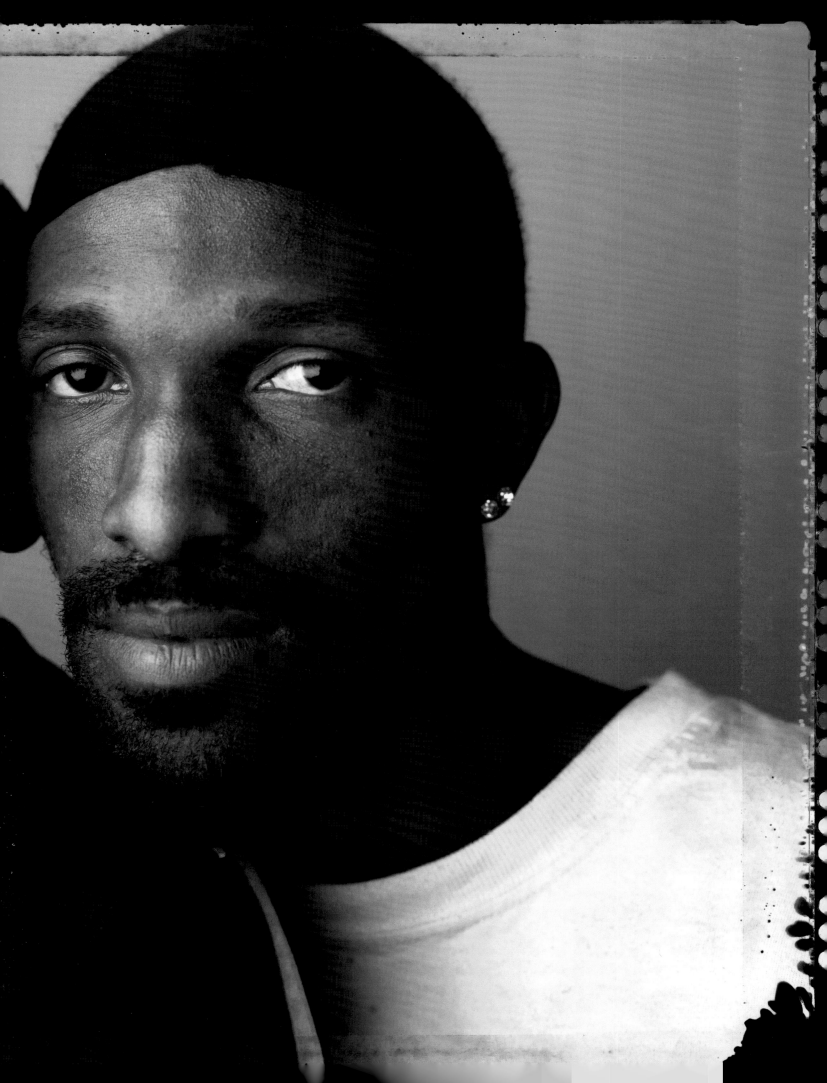

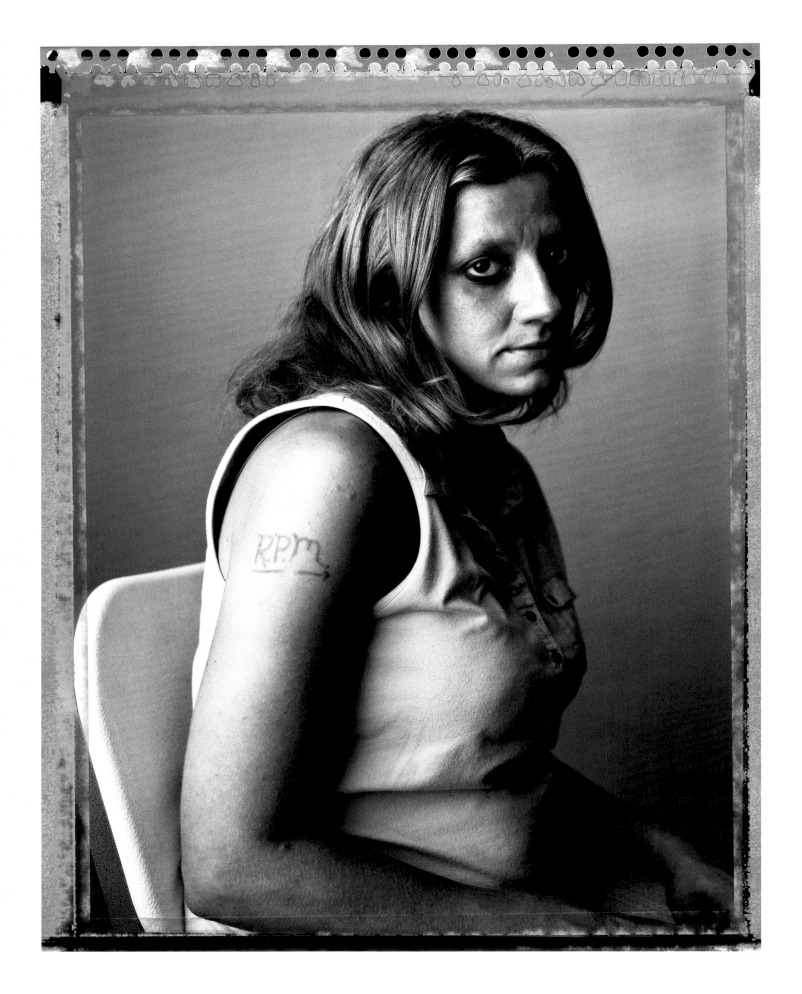

Maybe We Are

Maybe we are all members
Of an orchestra that is merely
Tuning up
And our curious trails
Are random scales
For a music that has
Yet to begin

Coffee

Steam from the coffee
And the stirring of the cup
The spoon going round
Says giddyup
Giddyup

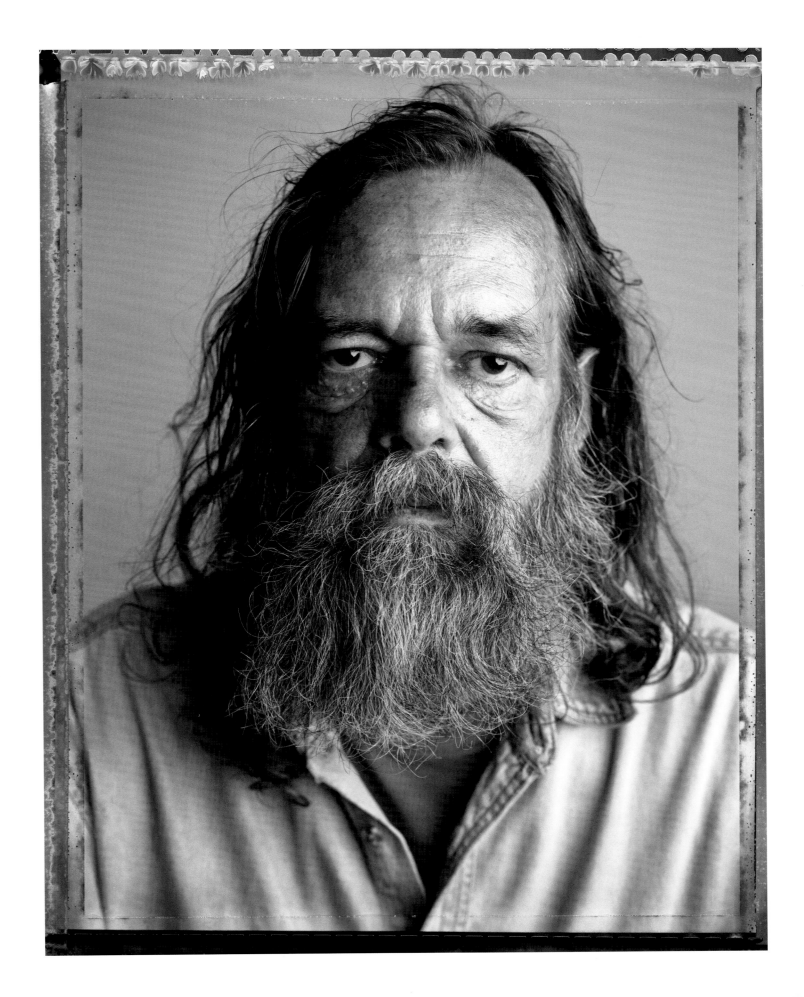

MICHAEL BUTLER

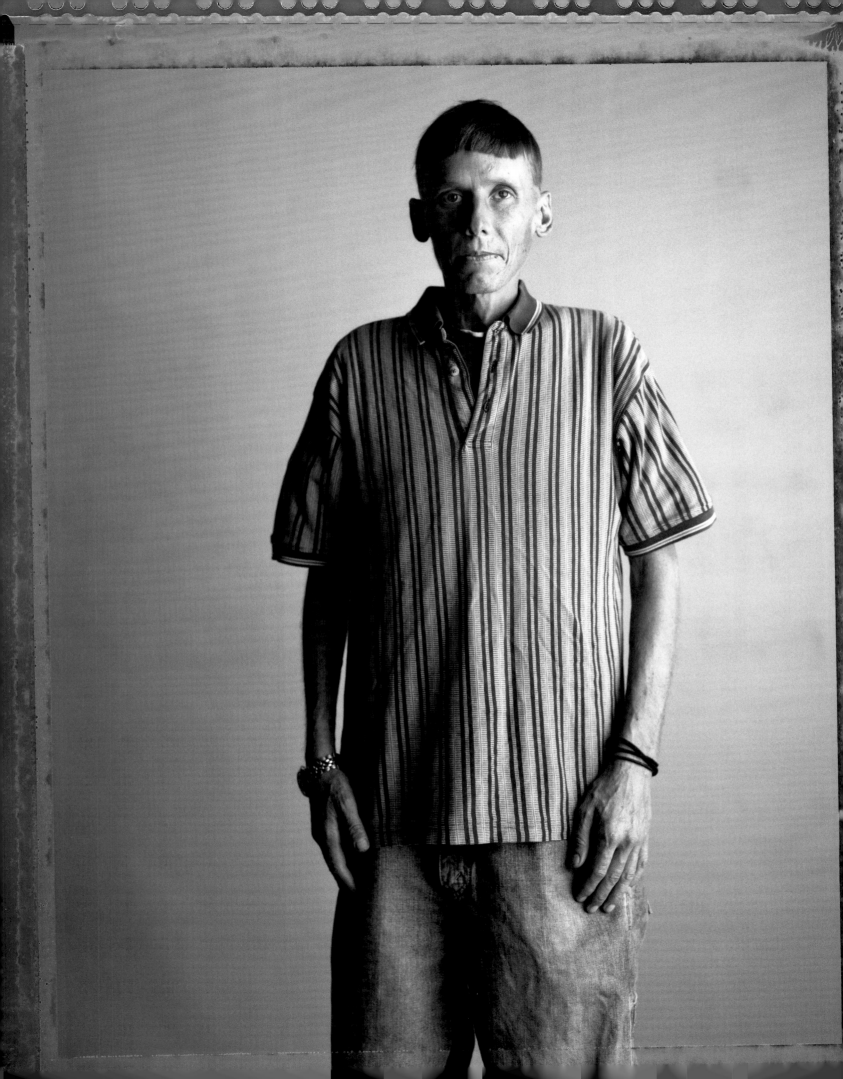

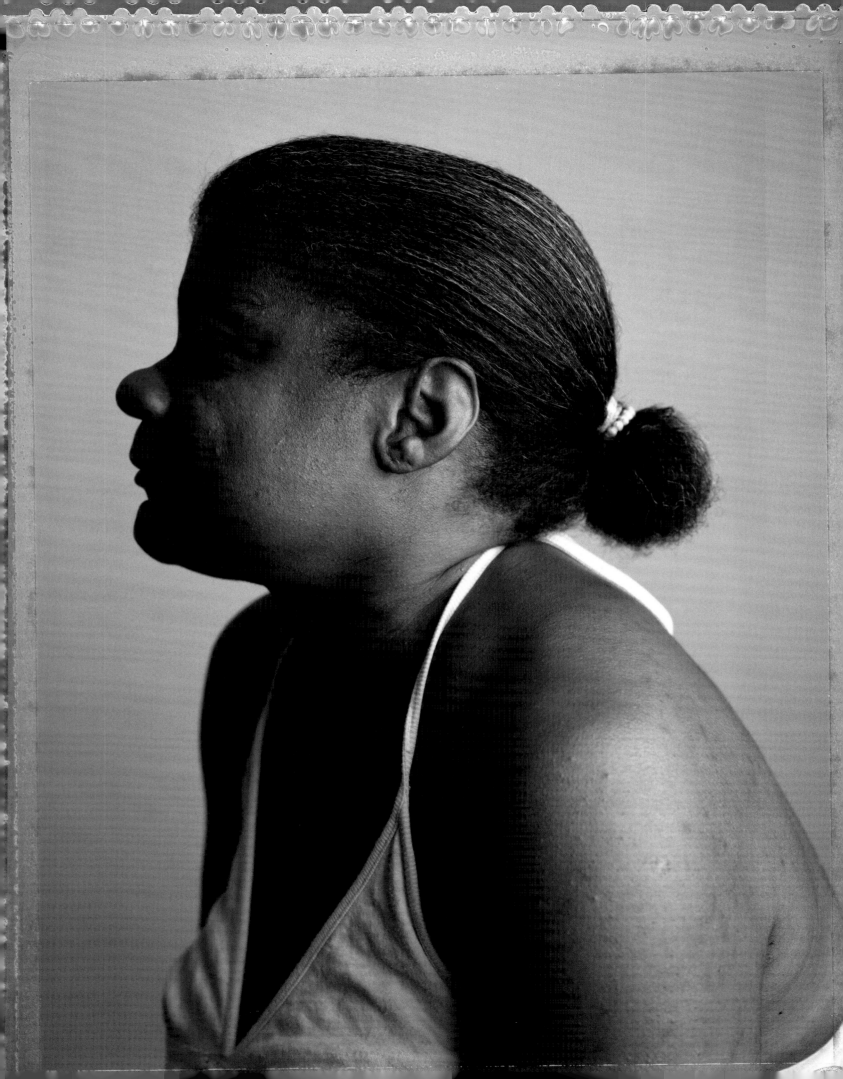

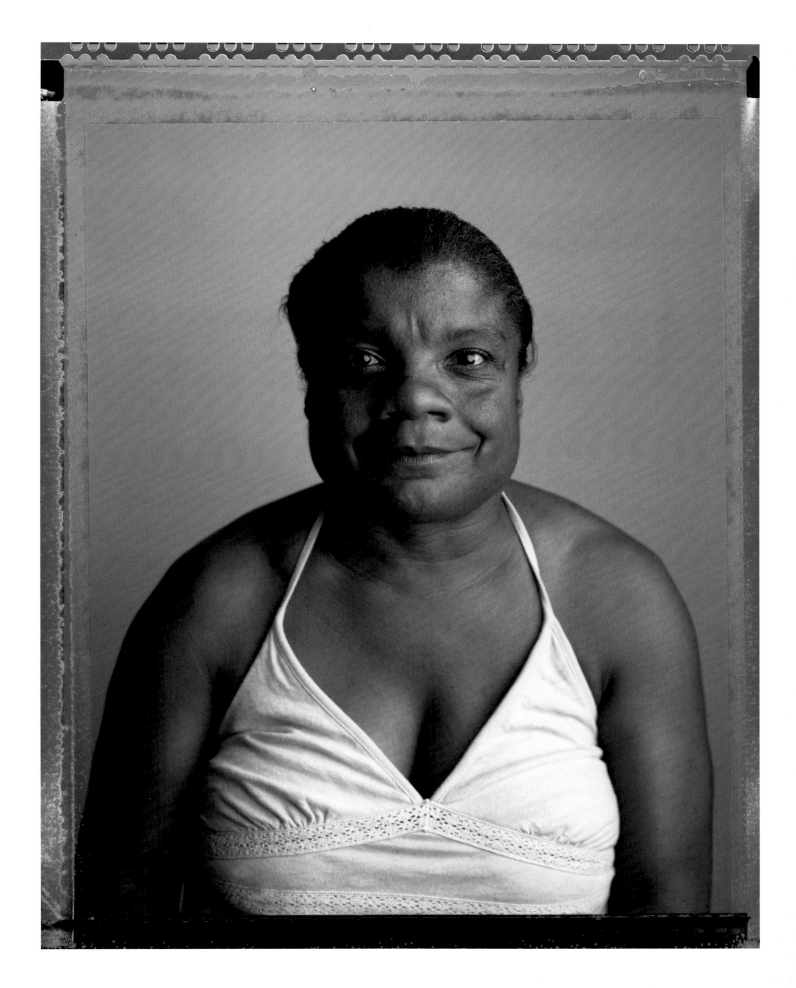

TANYA DUDASH

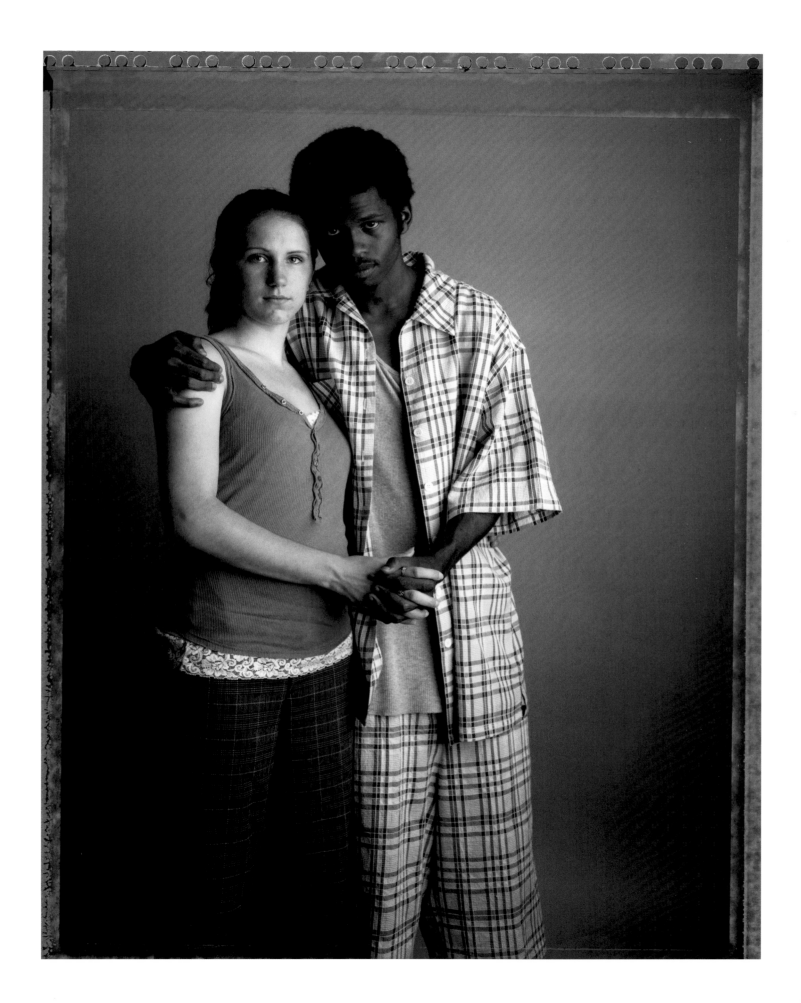

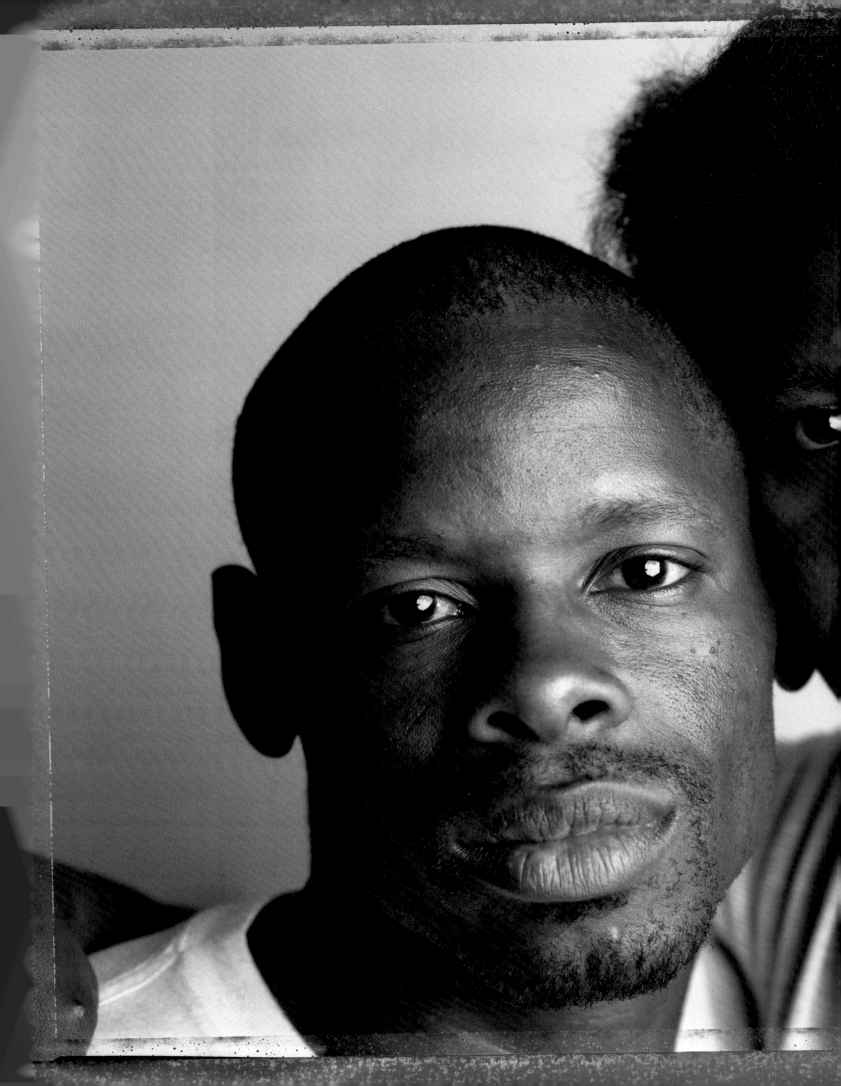

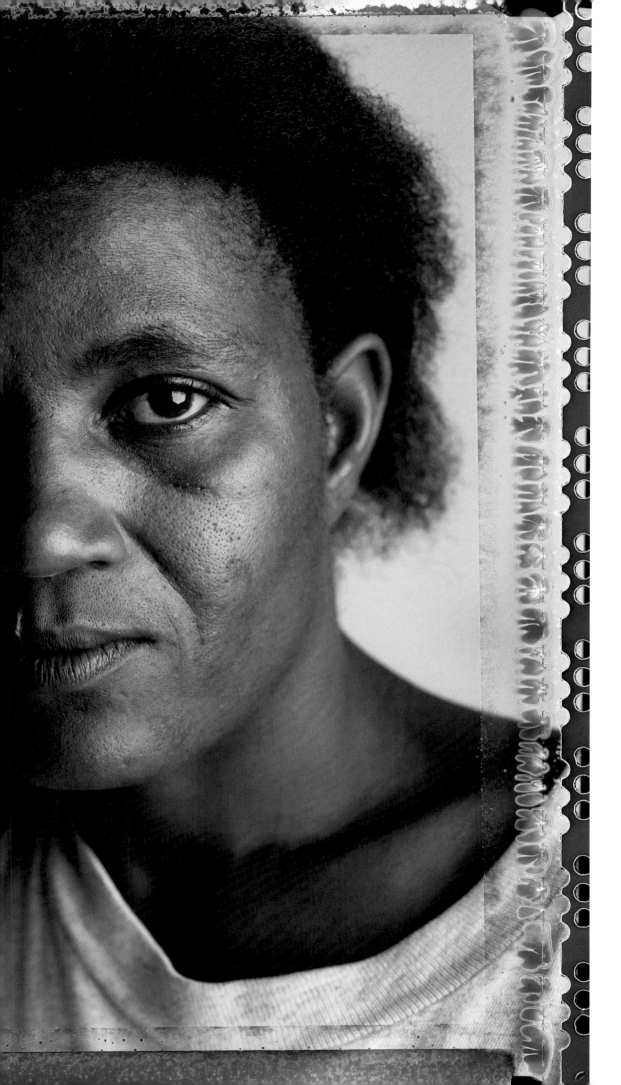

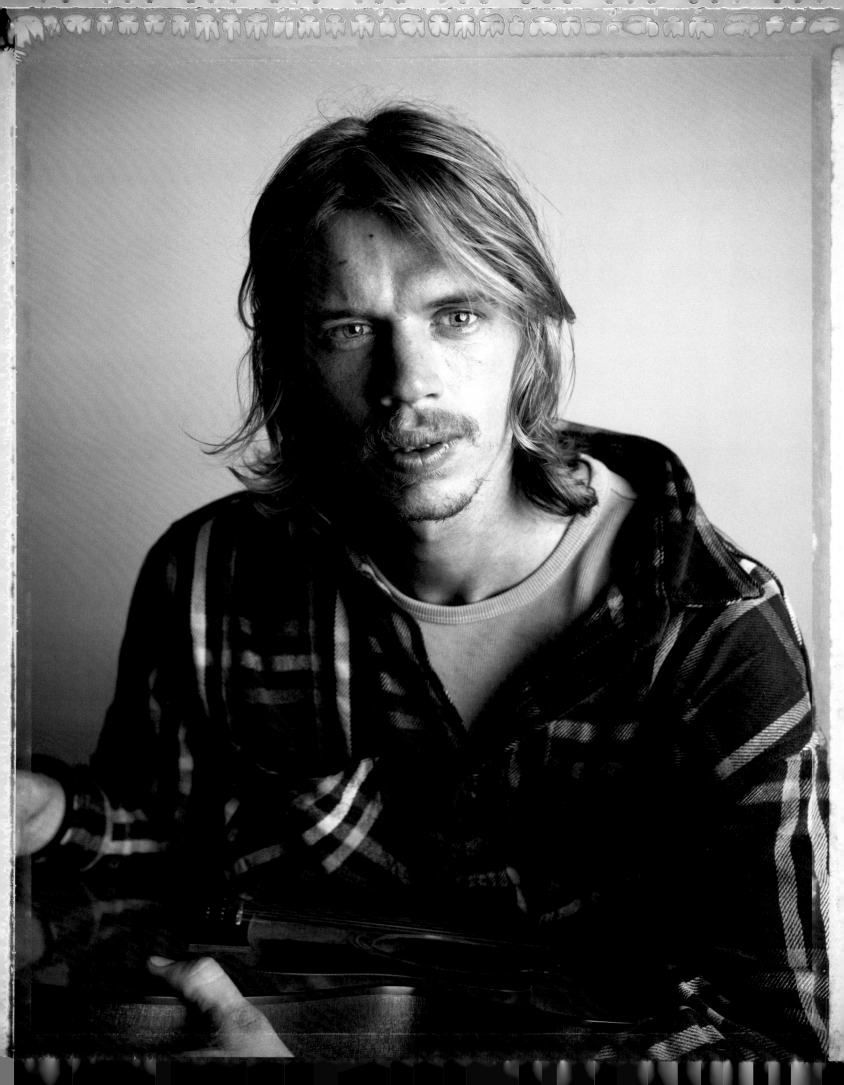

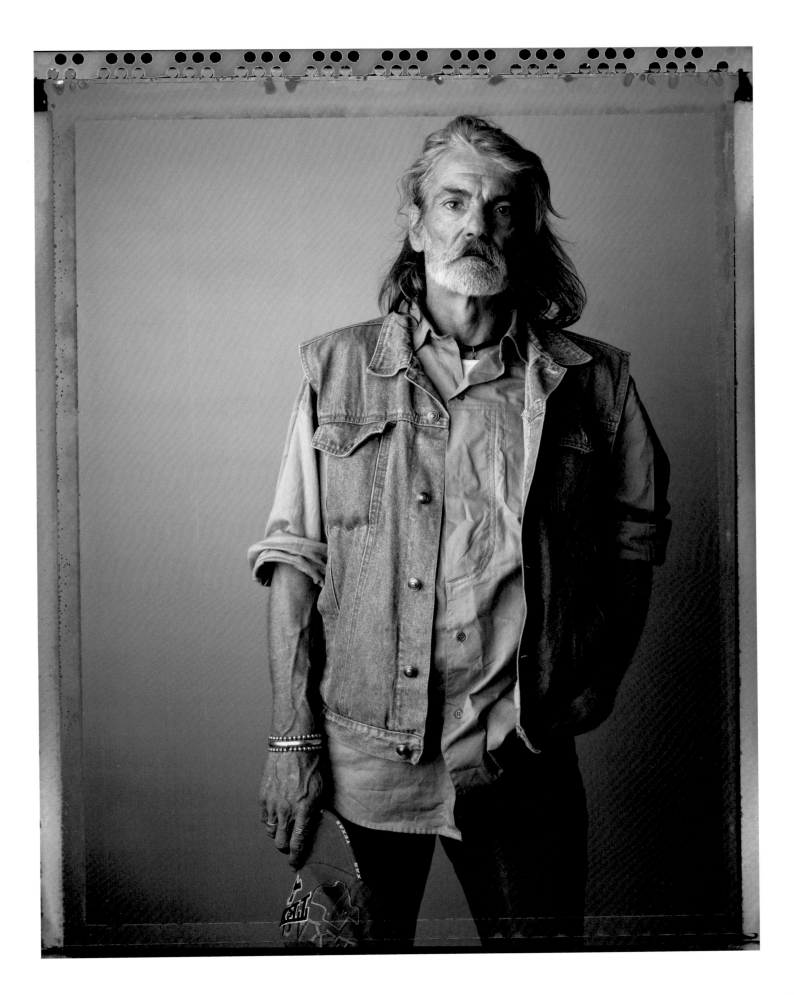

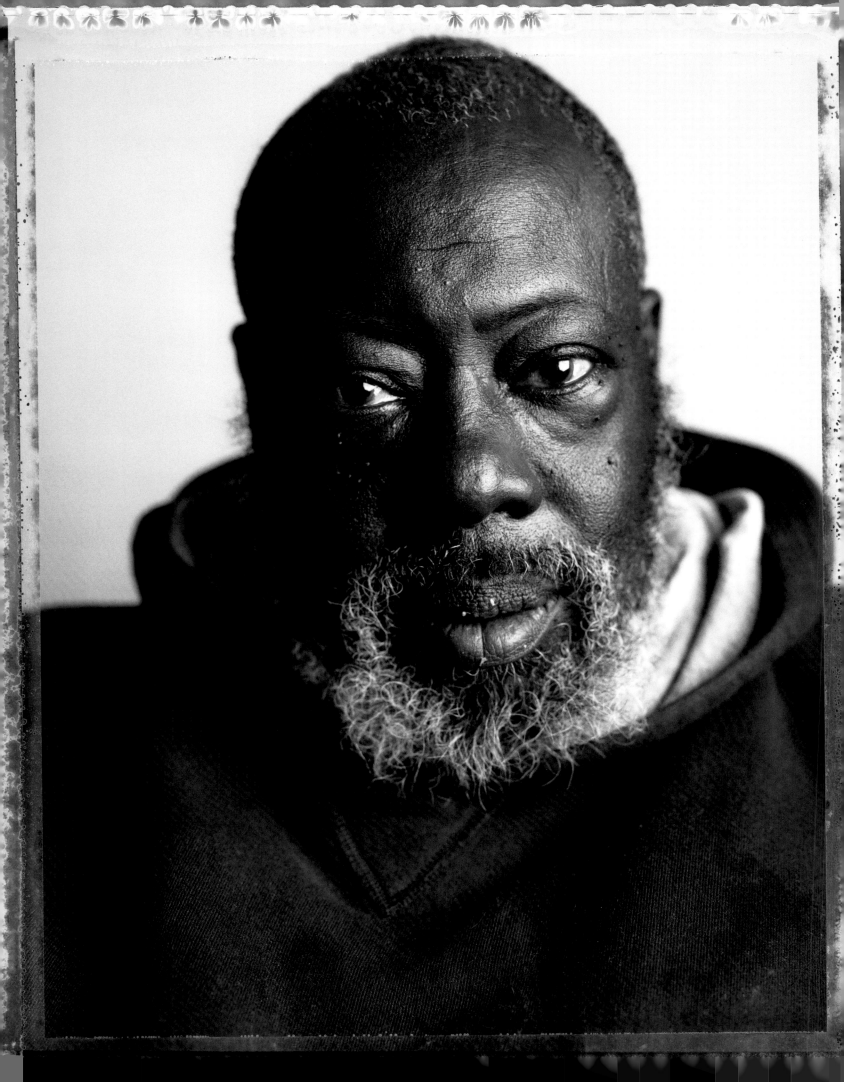

EDDIE RAY WHITE

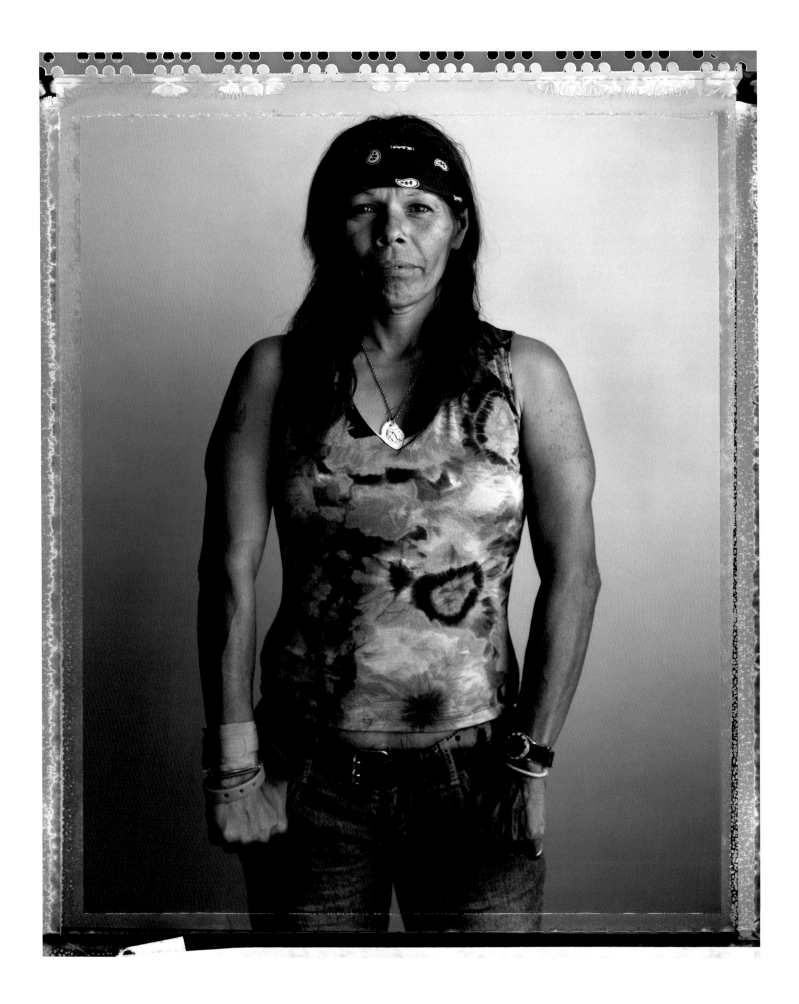

Lotto

Every now and then
The world just makes sense
Every now and then
The world makes sense
A melody is formed
By eight random tones
A monkey at a typewriter
Composes a poem
And a homeless man
Walks into a 7-11
Plays his mother's birthday
On the Lotto and wins a million
Every now and then
The world just makes sense

Waiting

The cars thunder past
As I stick out my thumb
I am just waiting for
My good luck to come

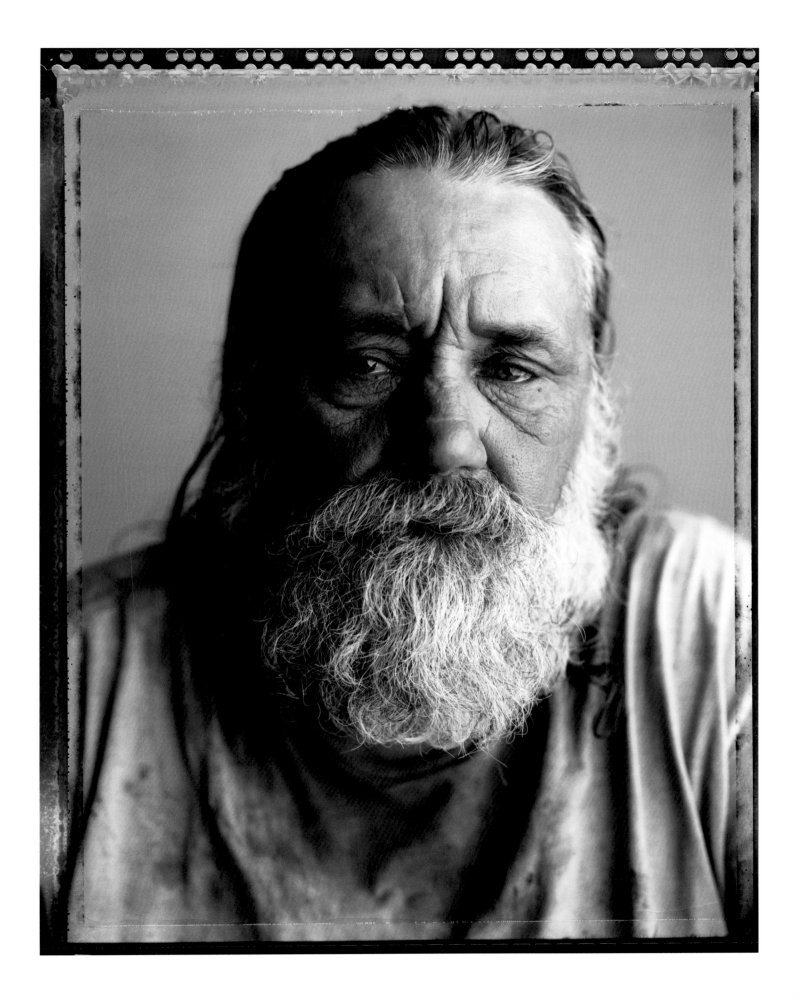

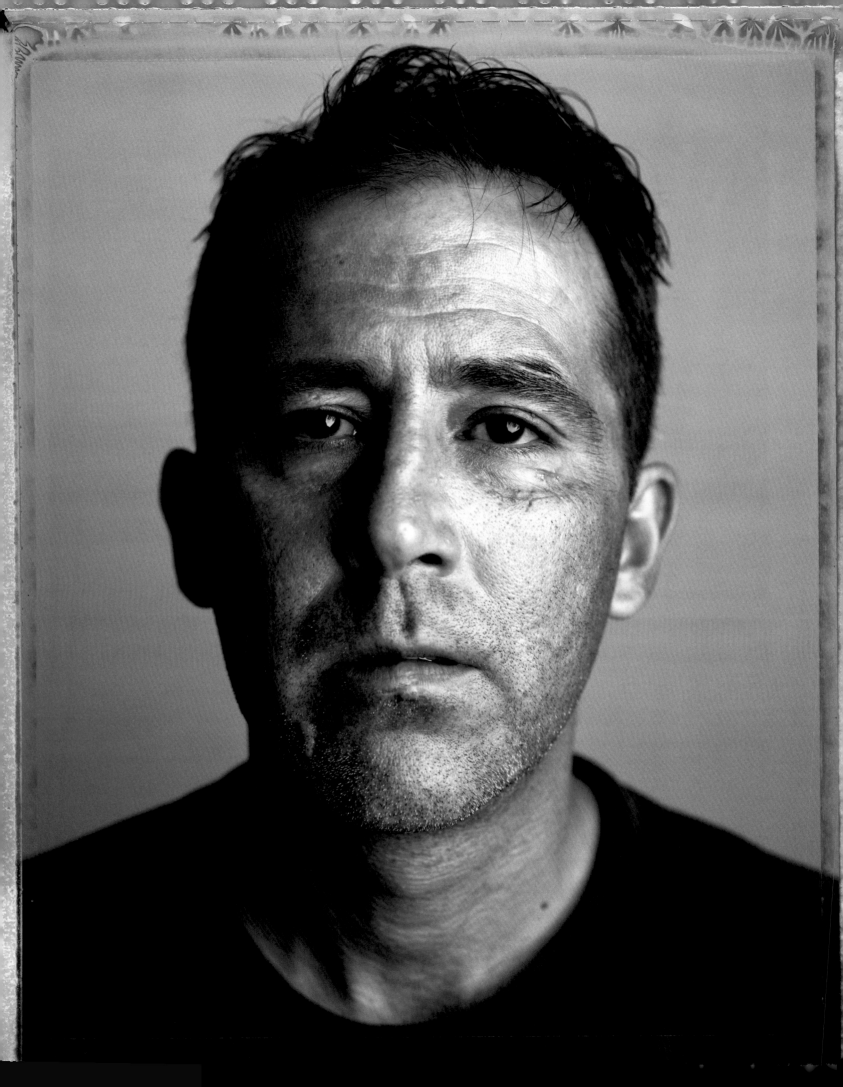

MARK ANTHONY DRAINE

FERNIE WALKER >

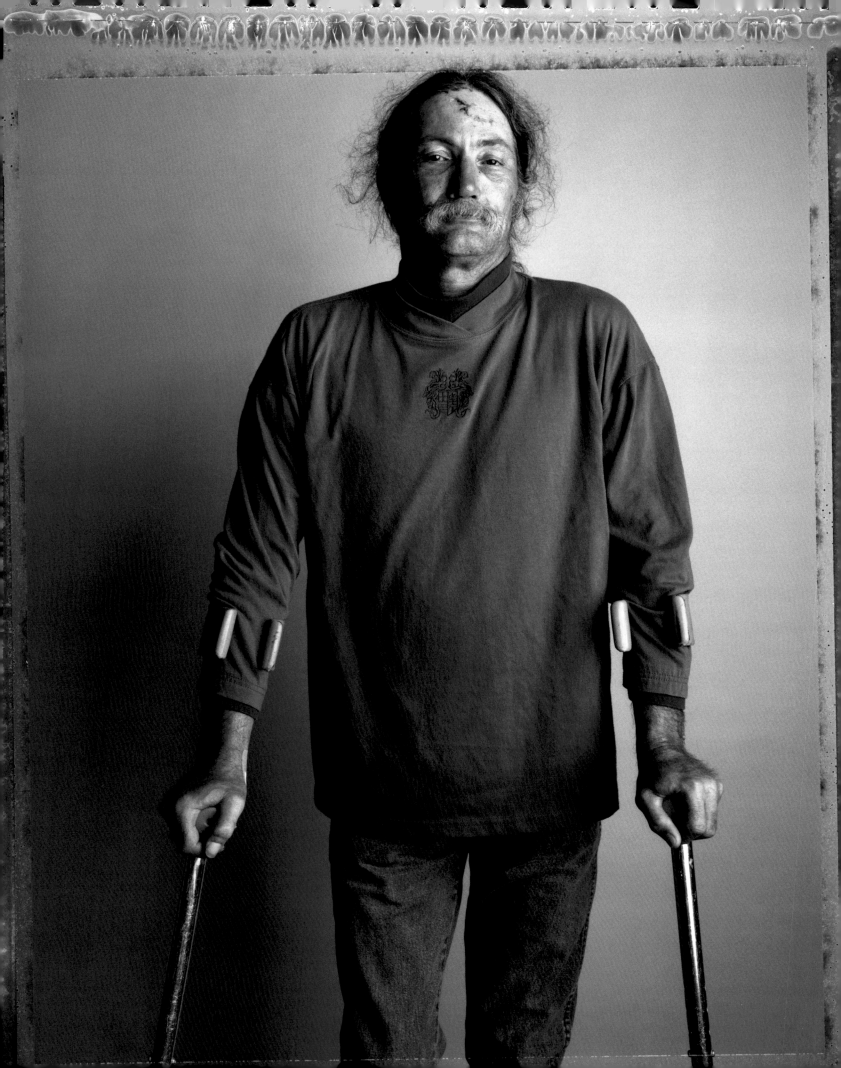

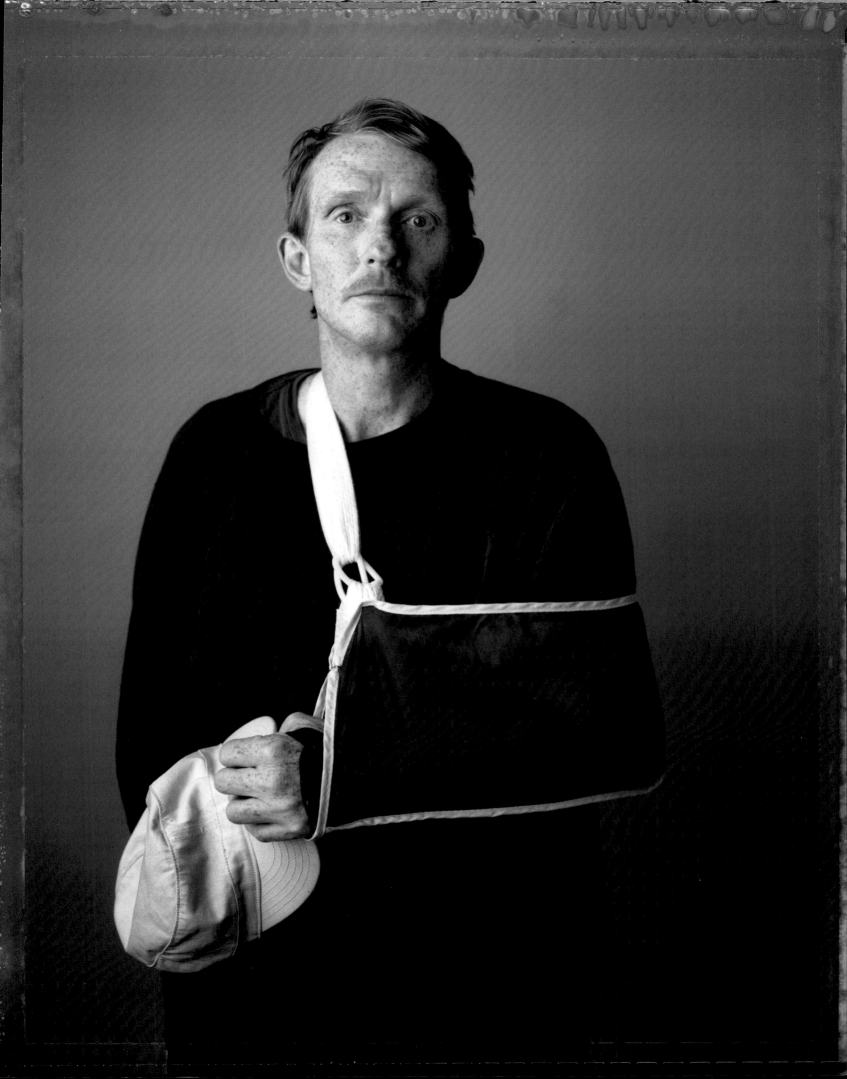

RANDY BIRCH

< FLOYD STONE

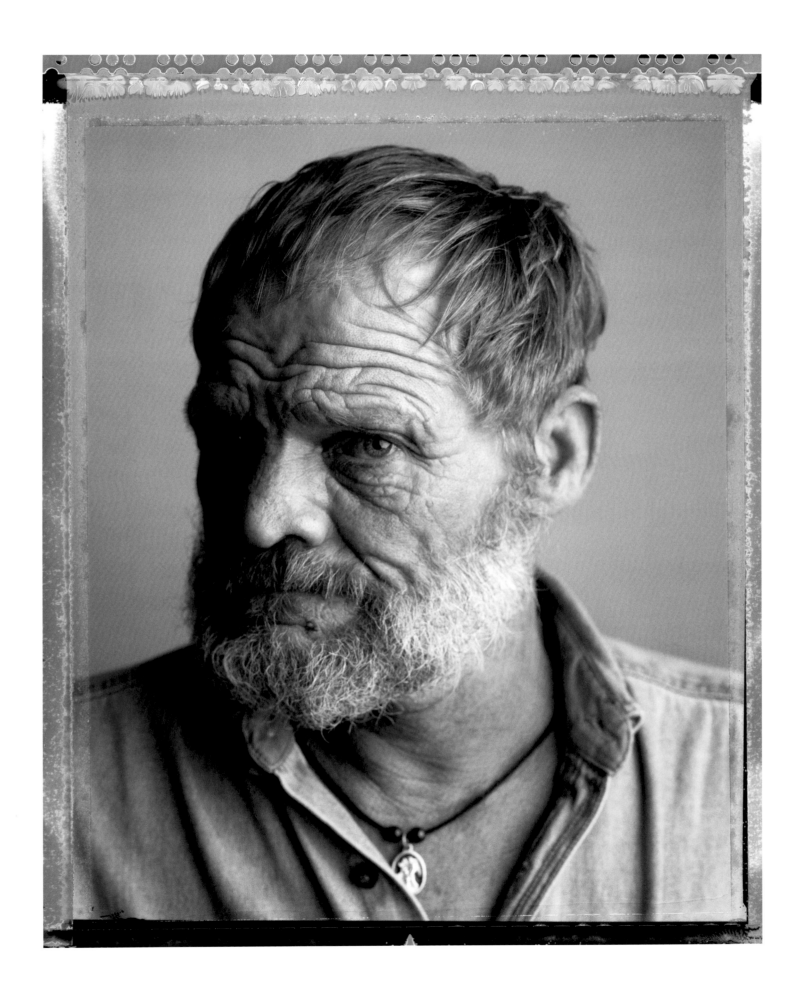

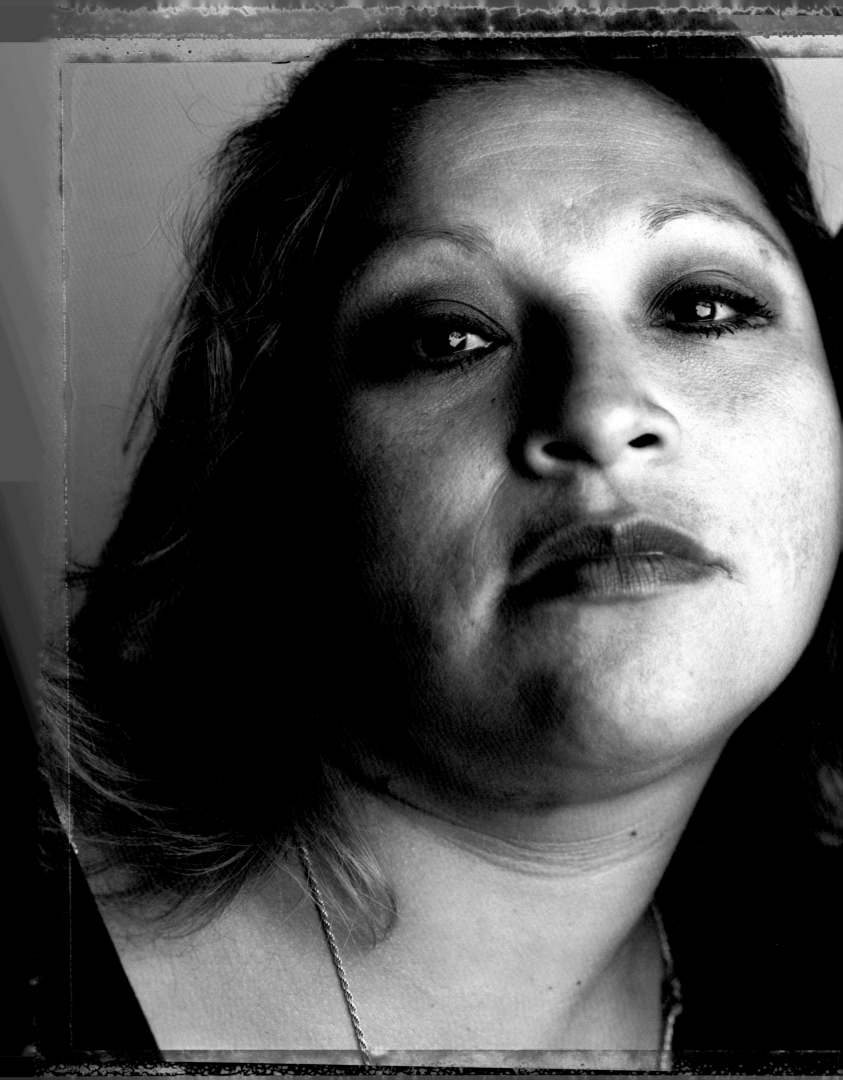

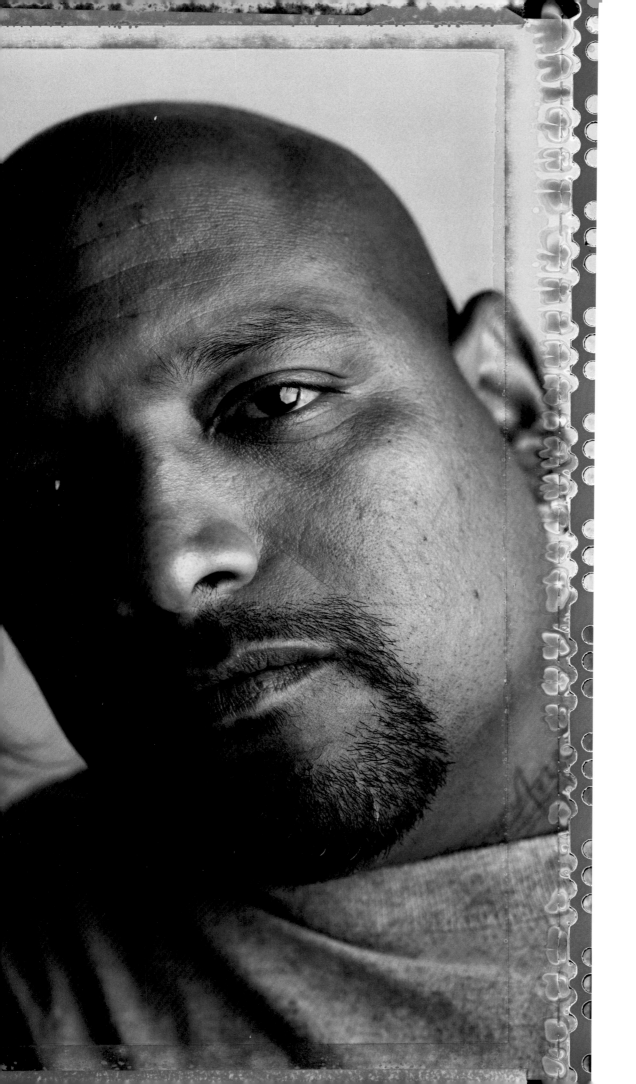

ROY CALDWELL

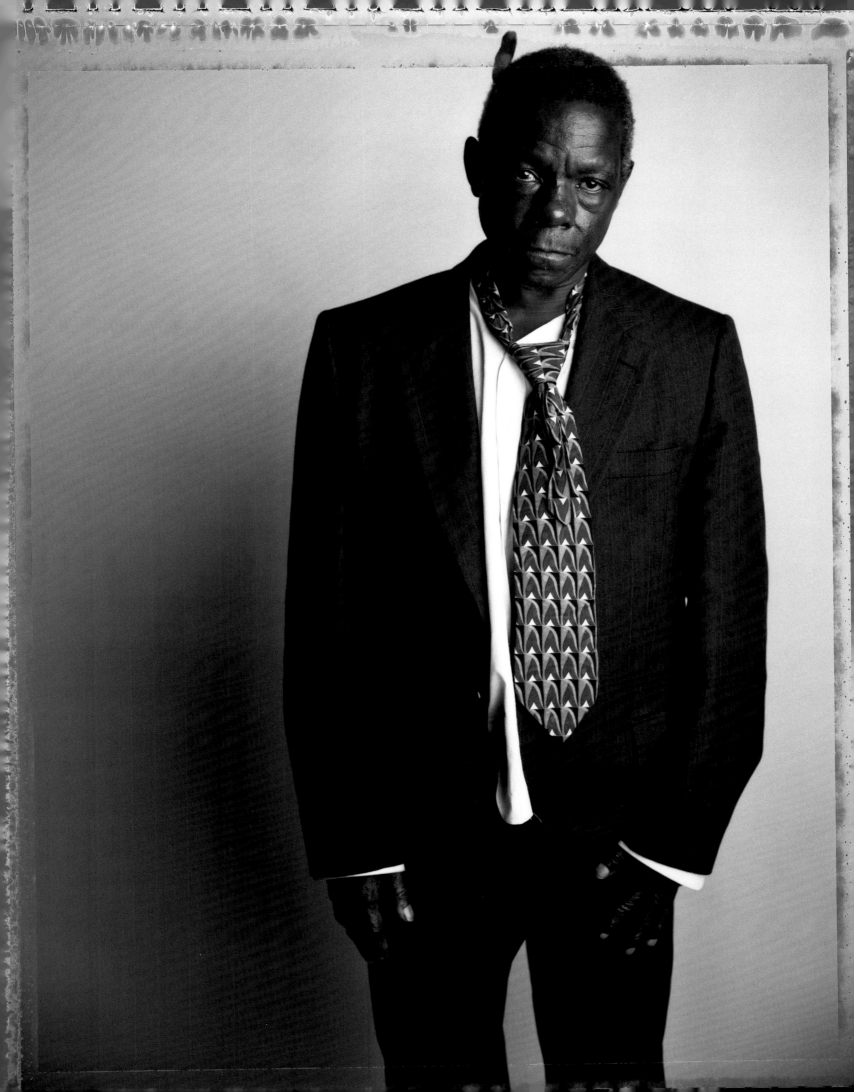

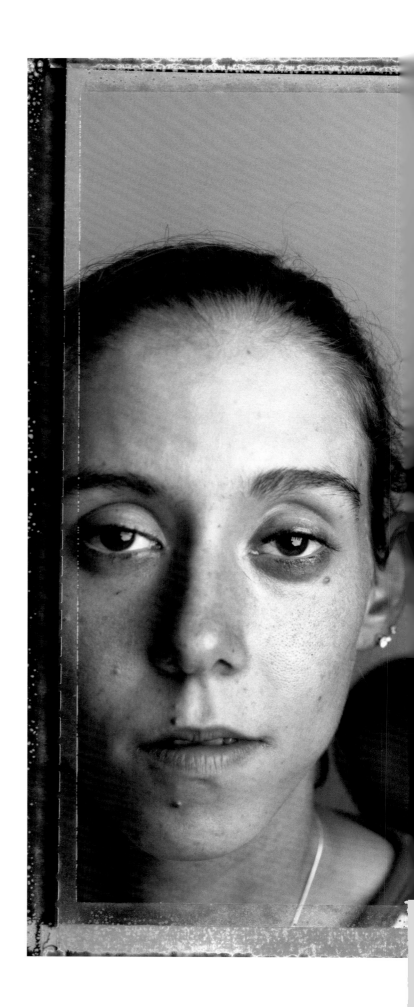

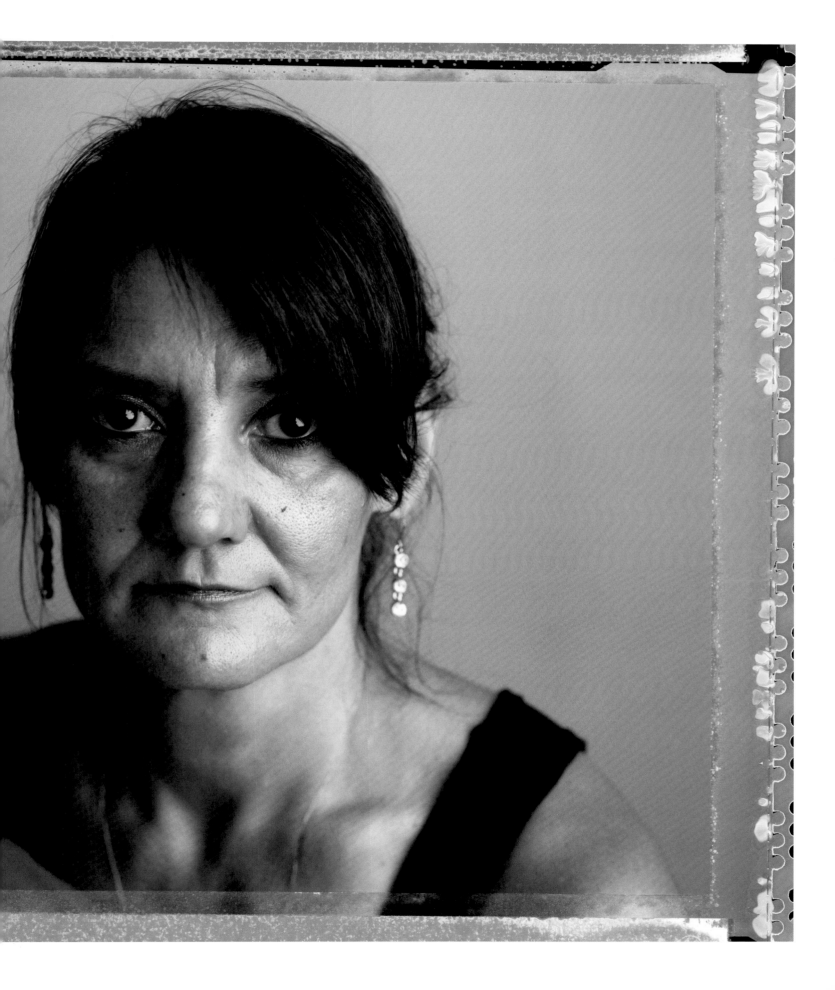

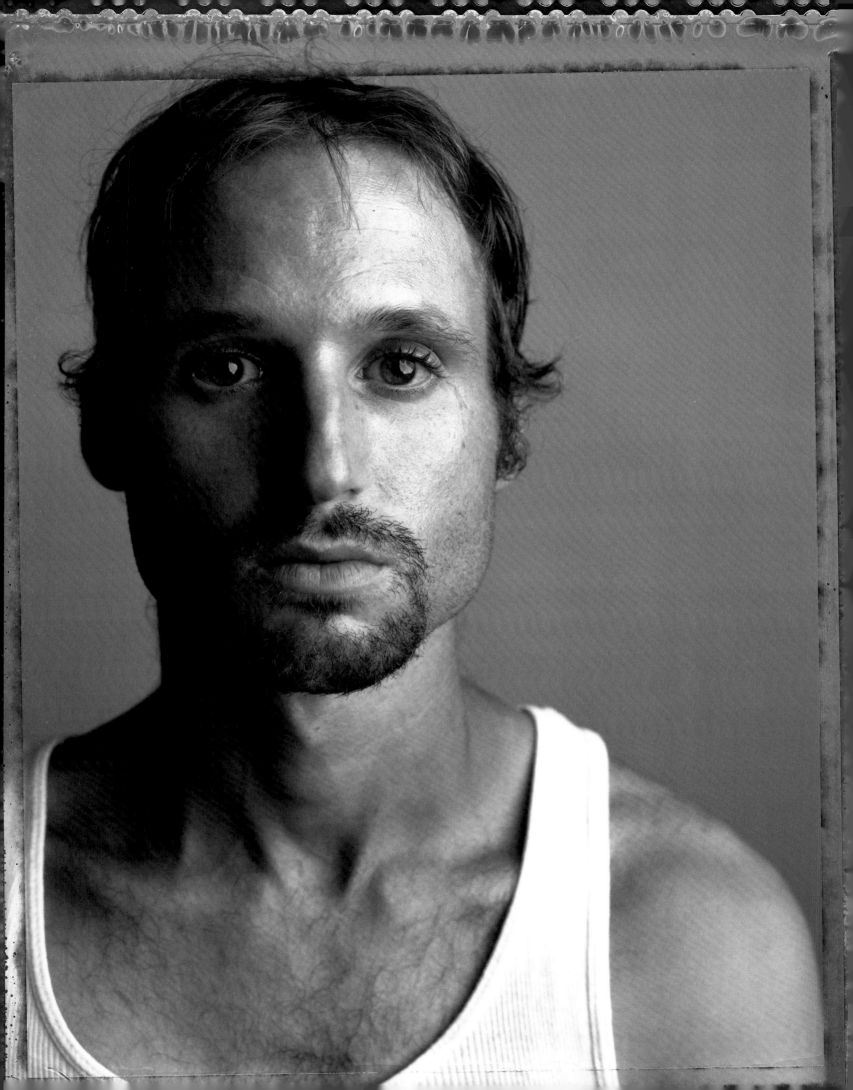

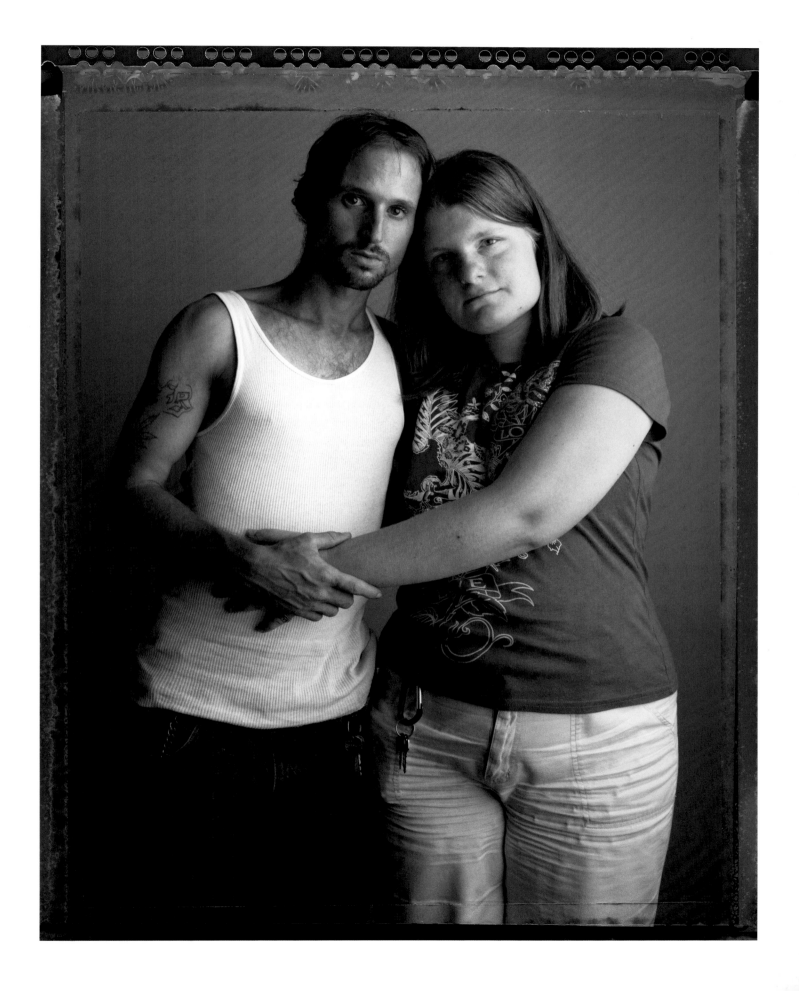

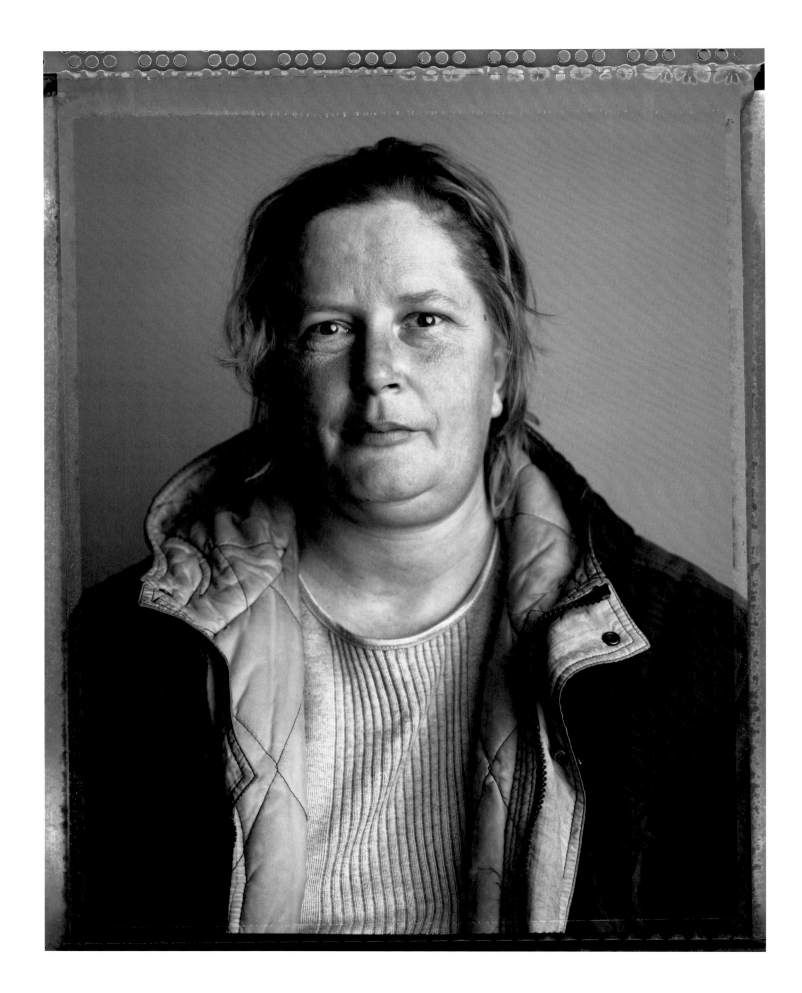

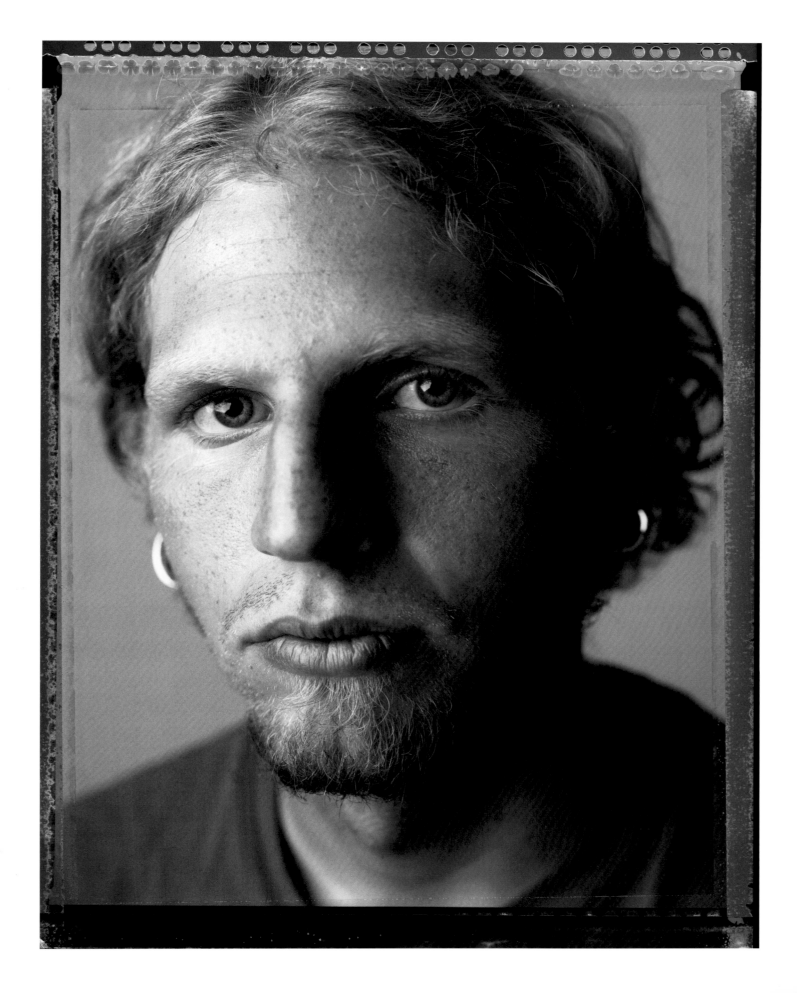

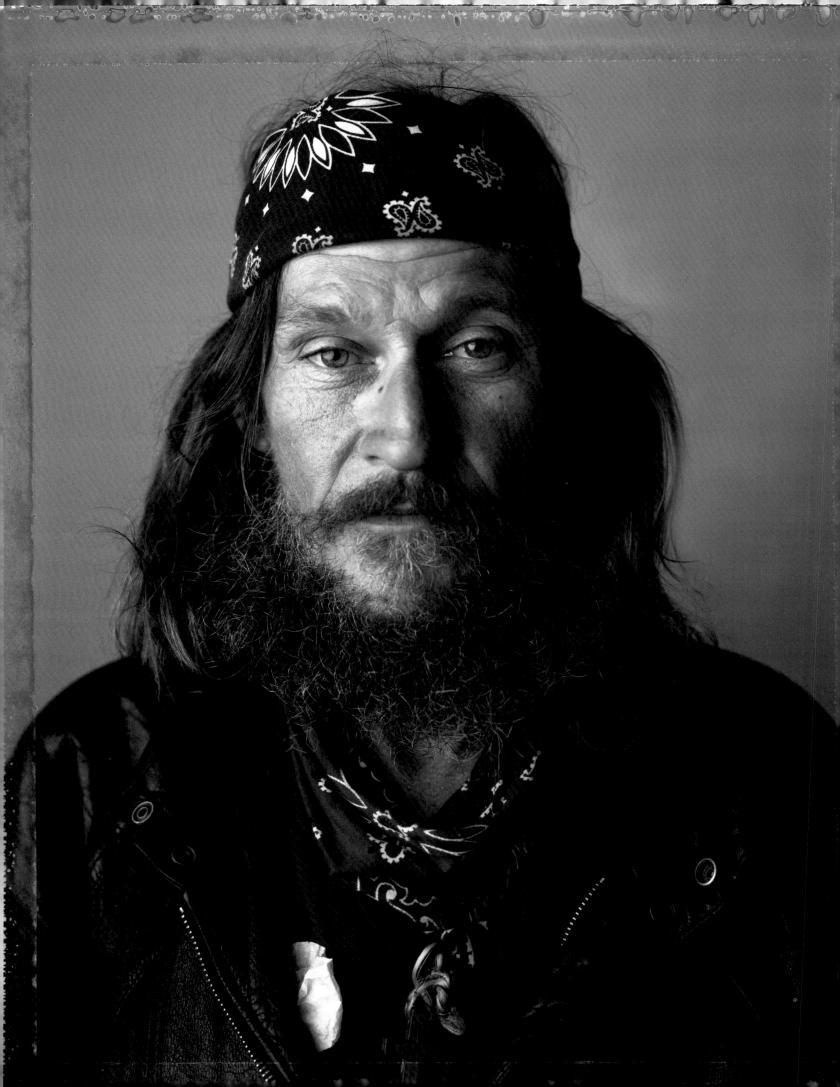

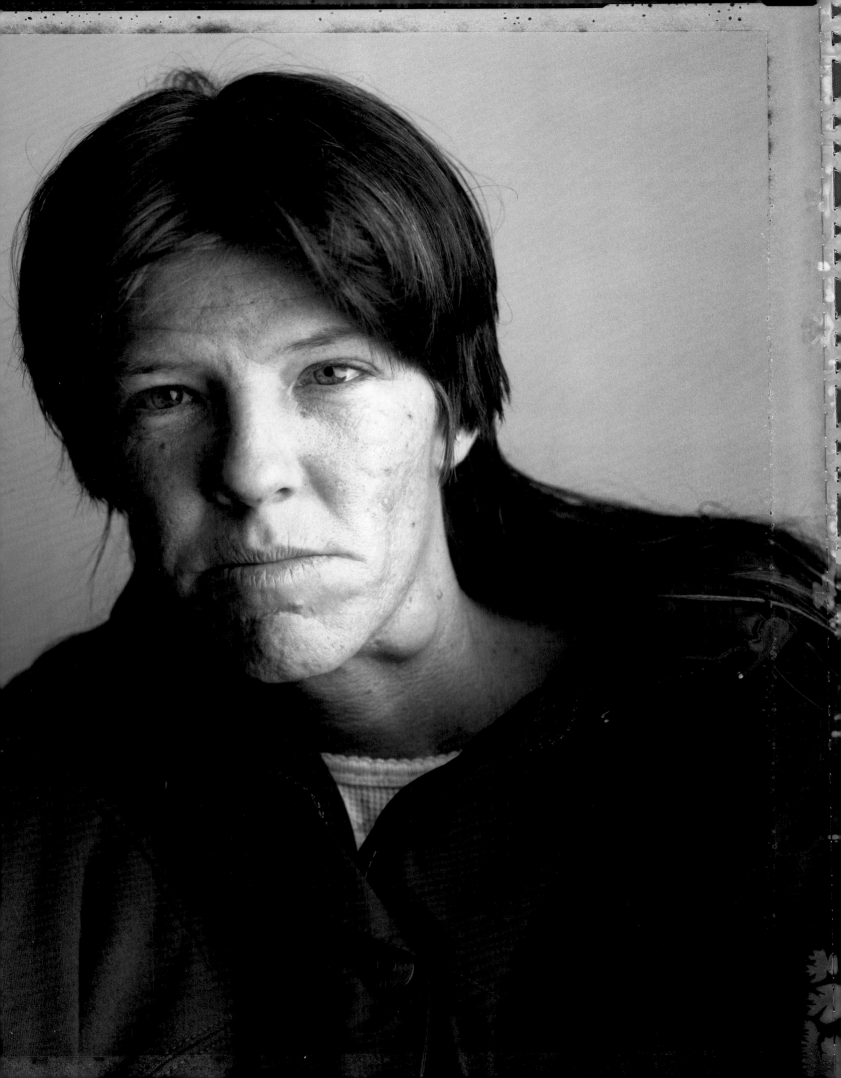

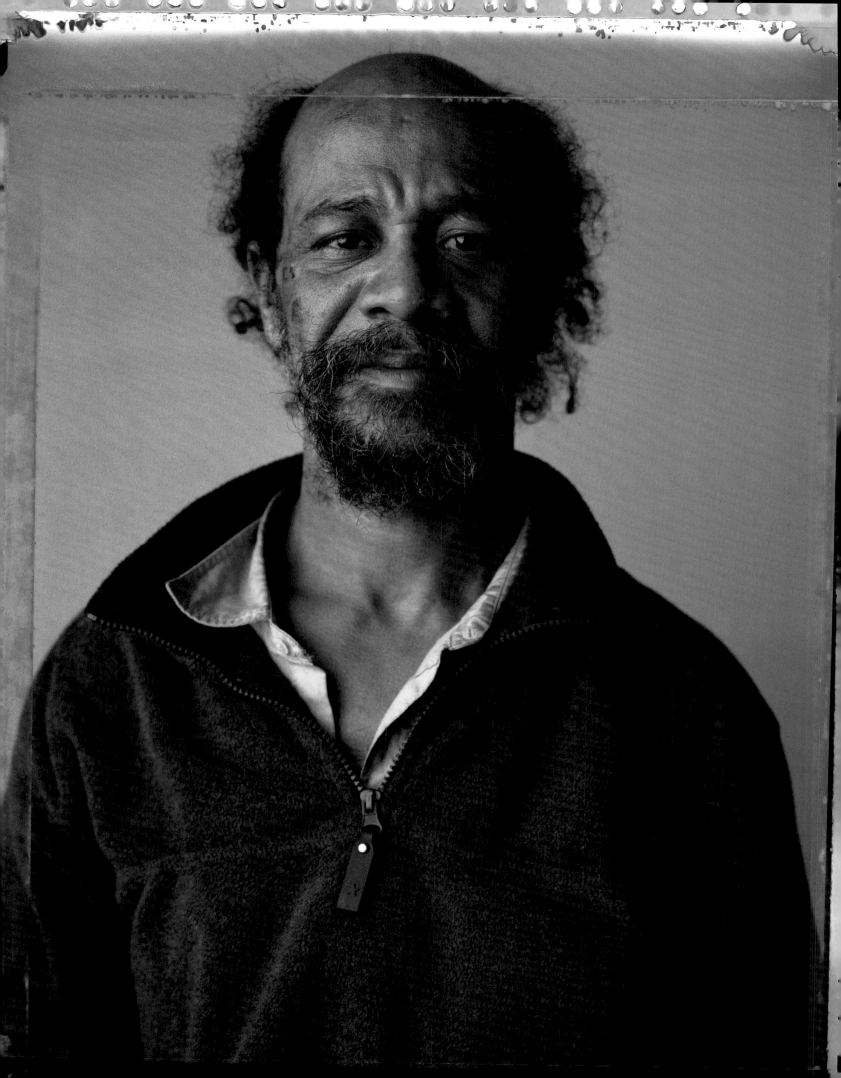

DON MCNULTY

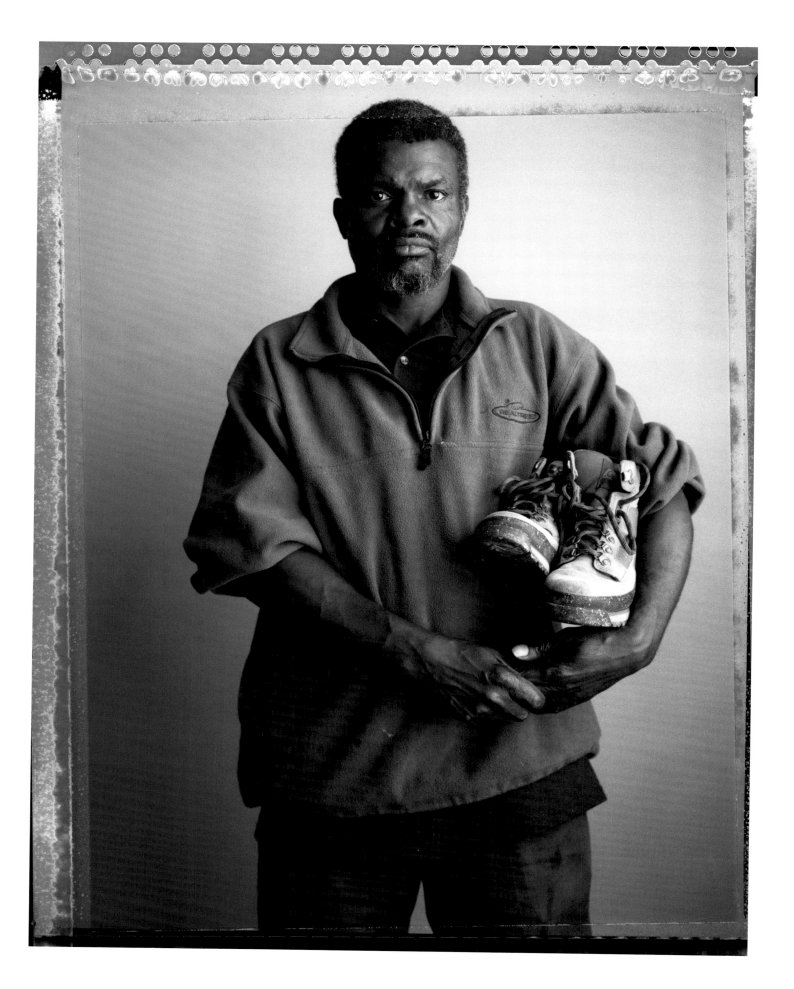

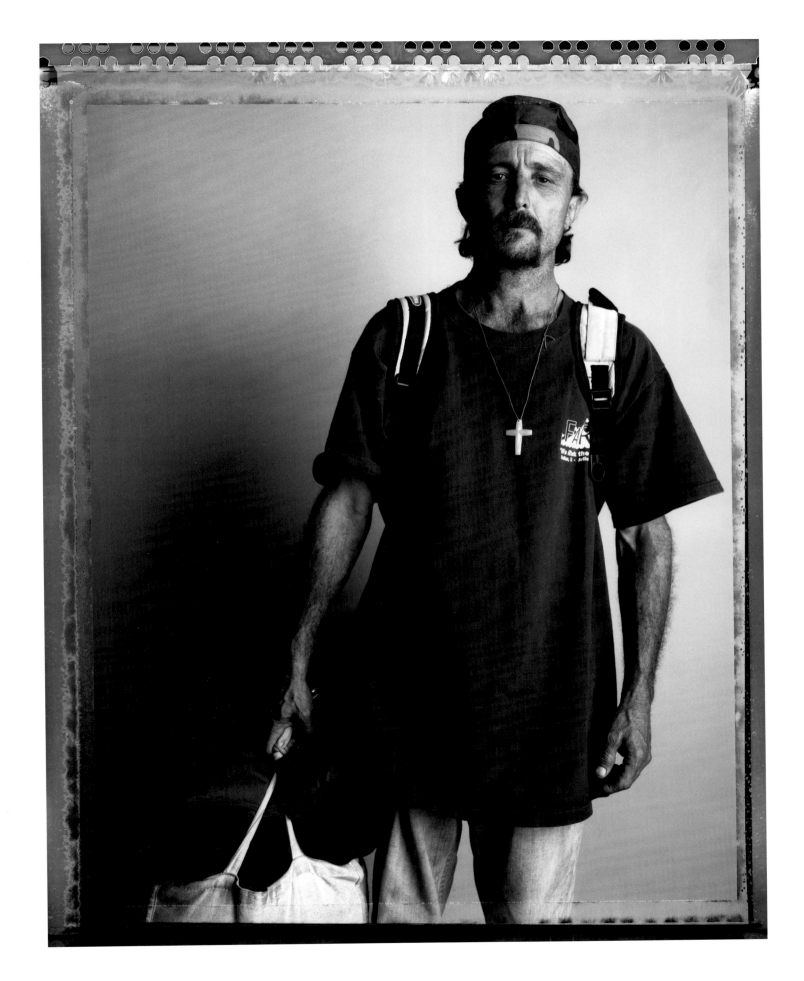

RAY BELL

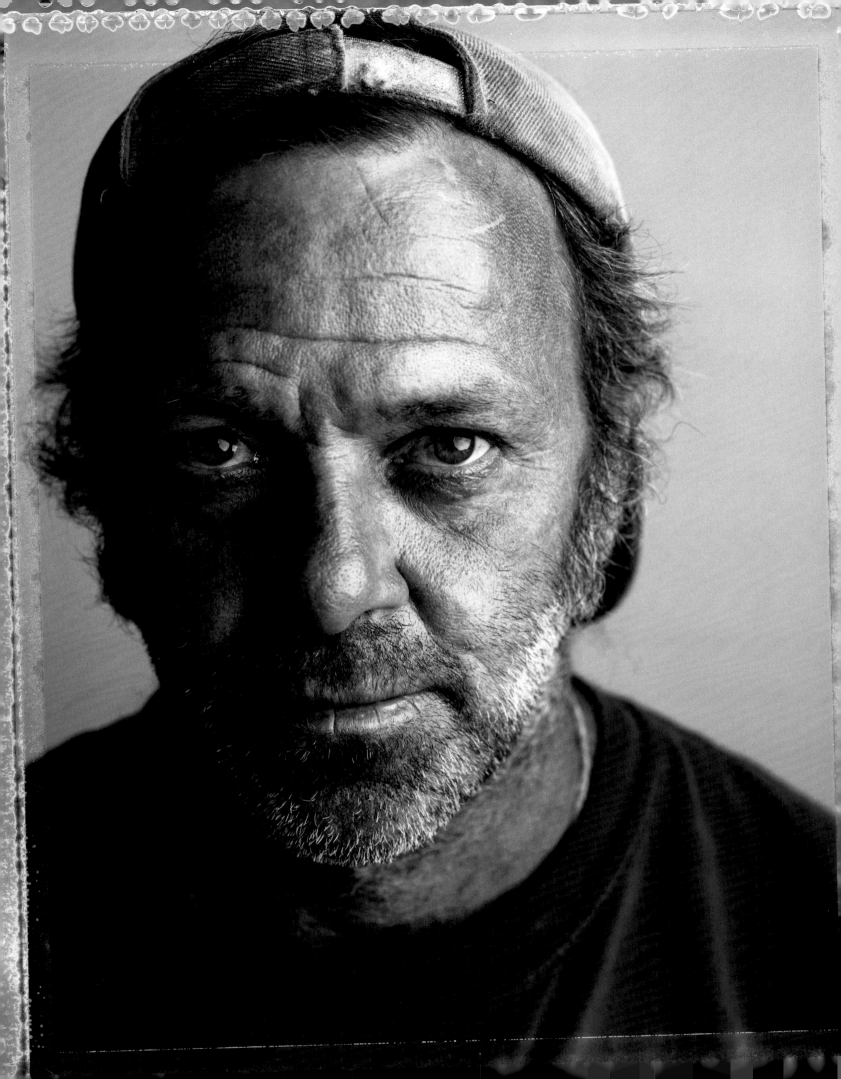

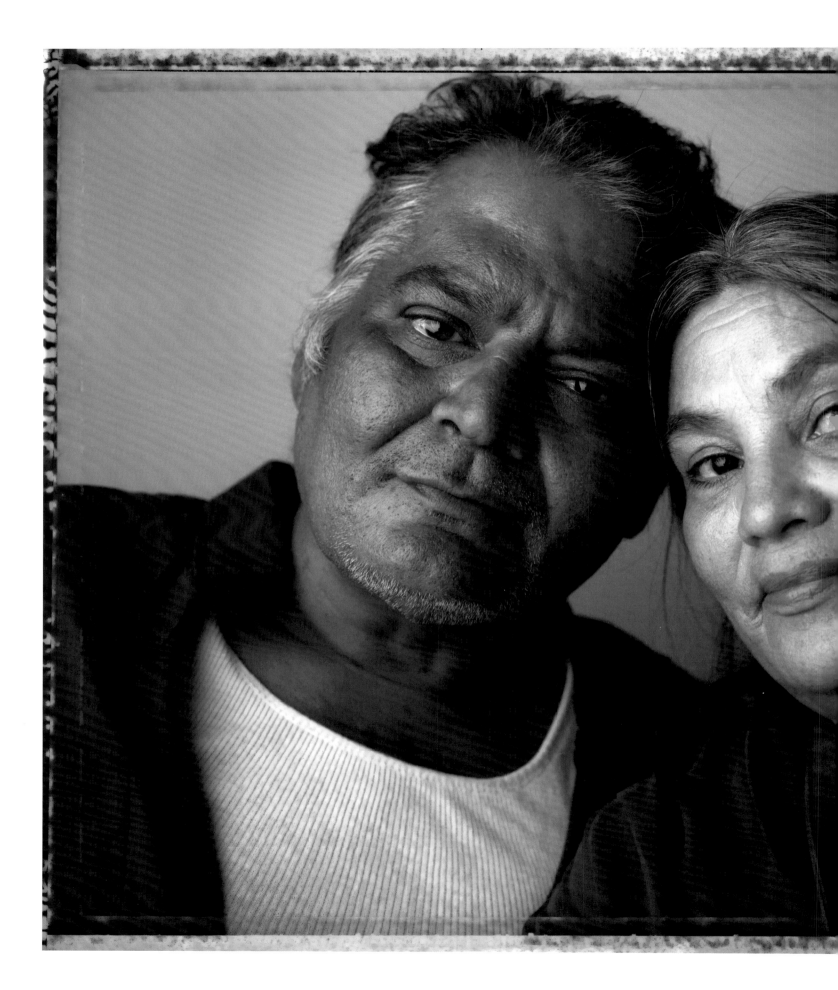

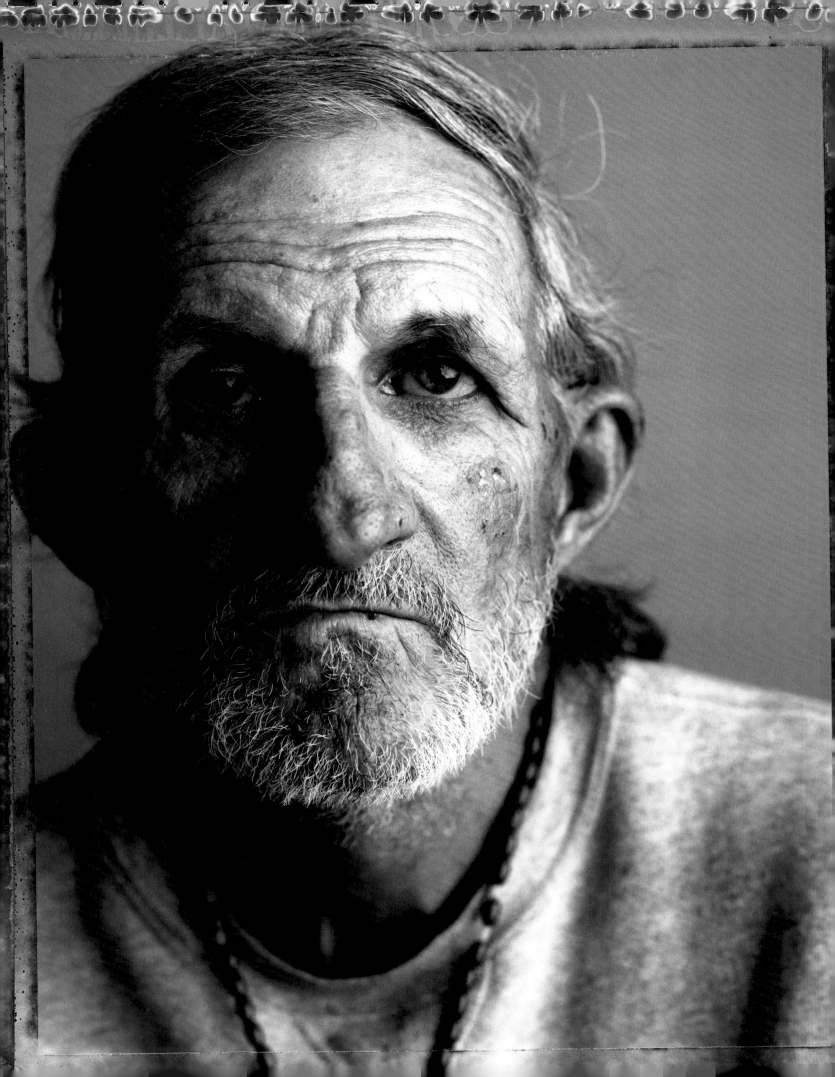

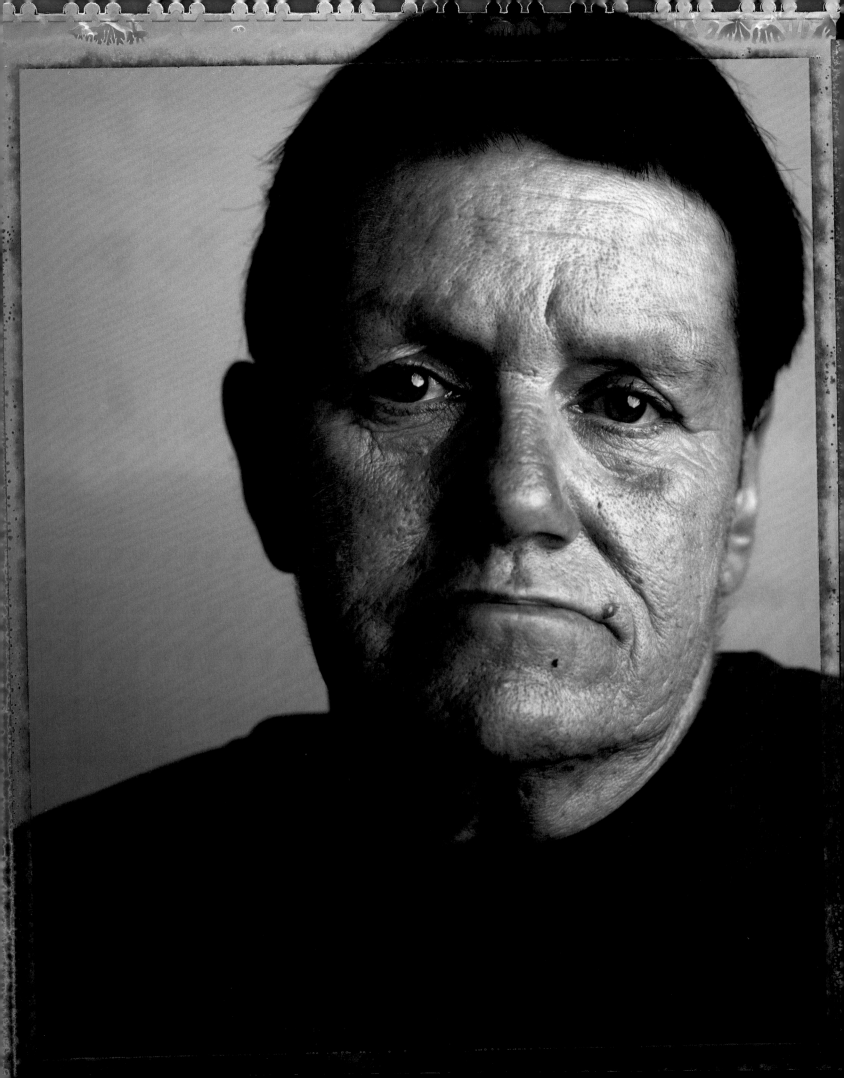

CHRIS TAYLOR

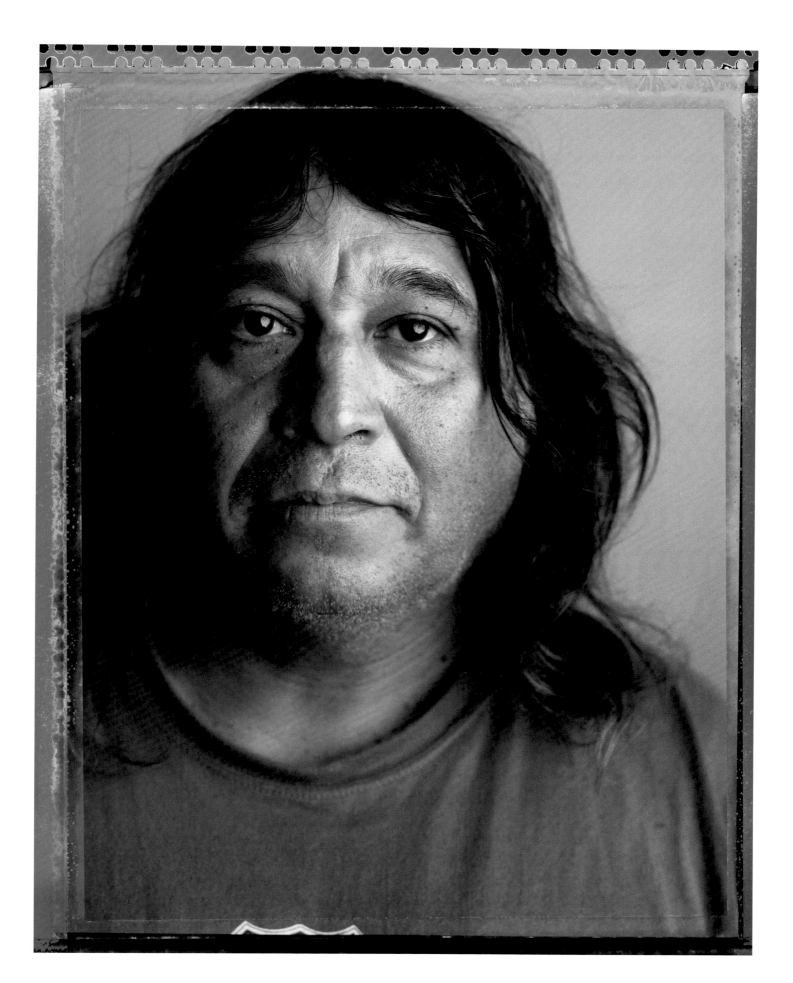

CHARLES MAYFIELD

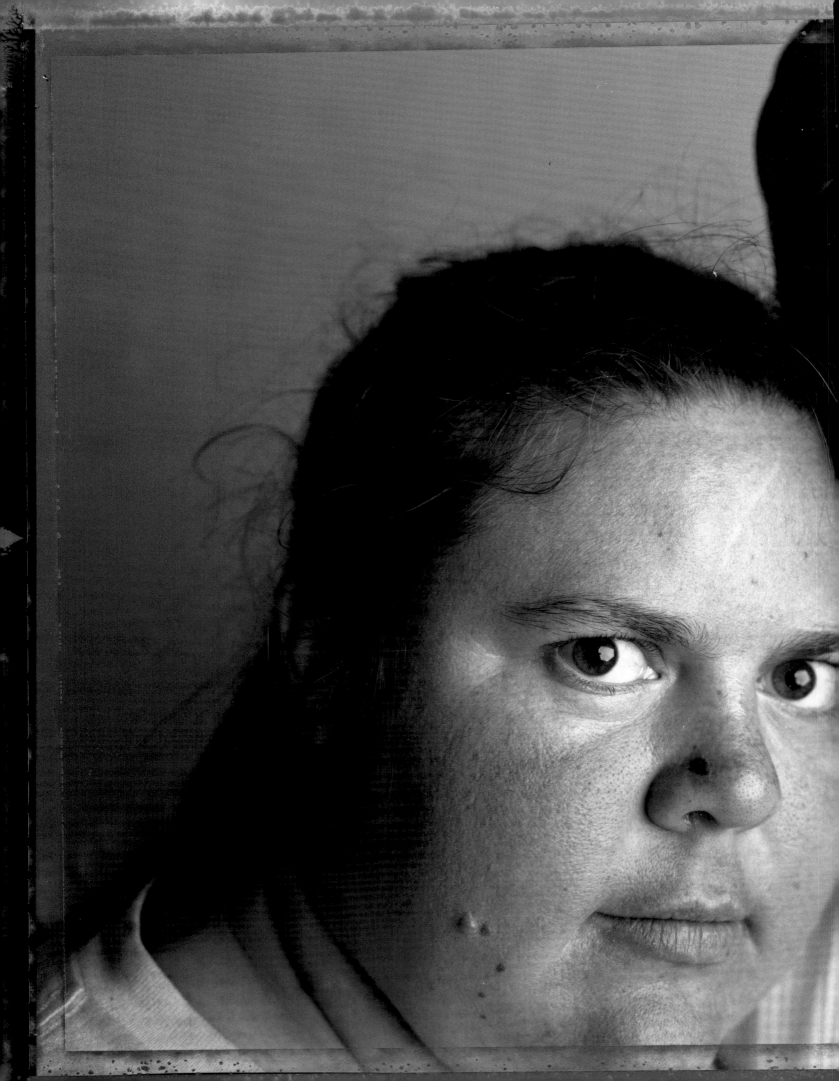

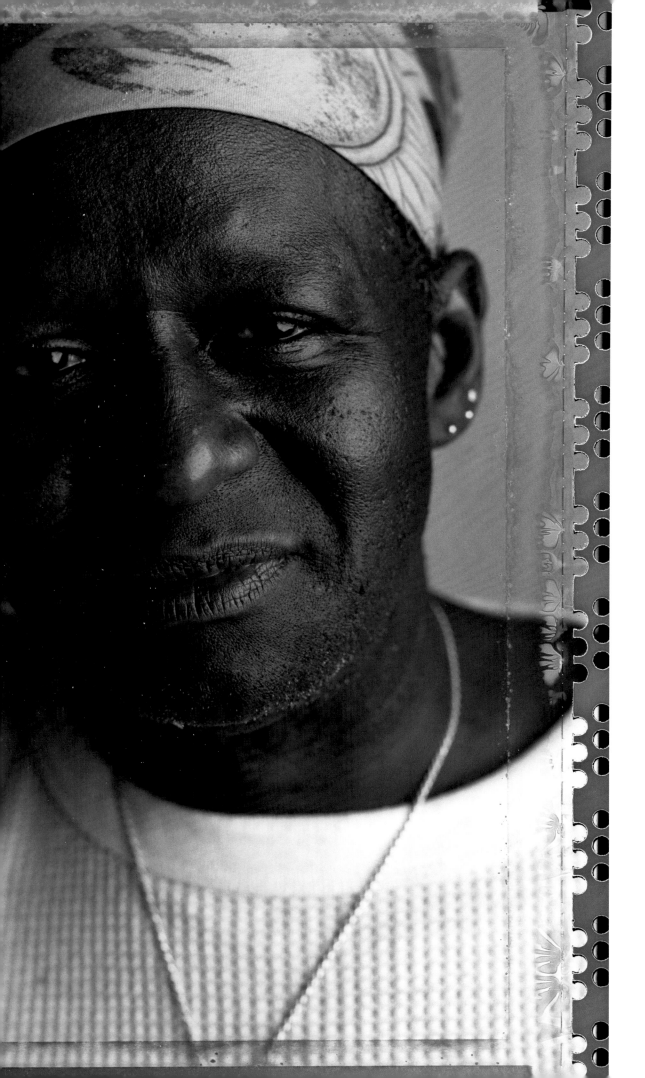

STEPHEN ROBERT BLAIR

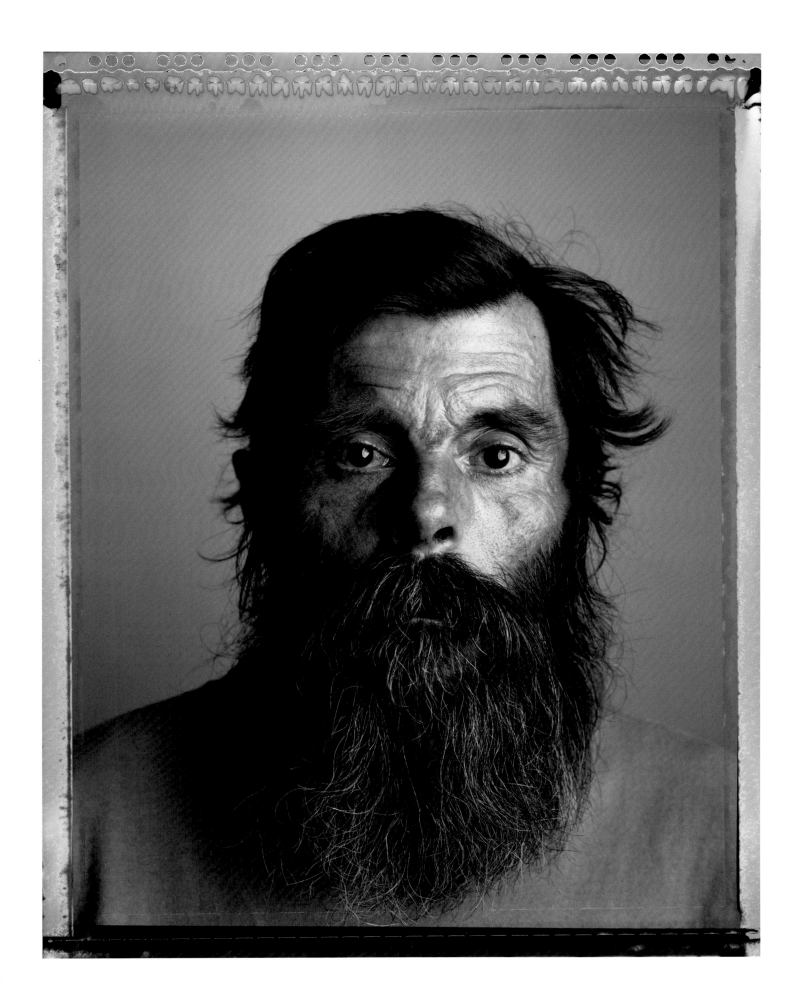

NOTES

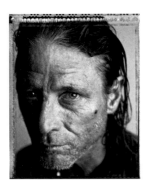

GARY FAURIES 49
Jefferson Parish, Louisiana
Photographed 10/2/07

"I've been in Austin since Katrina. My family lost its home in the hurricane. I was there when the hurricane hit. The whole time I knew God was there with His arms around me. It was devastating, but not frightening. I hopped a freight train from Houston to get to Austin. I am fighting to get my Social Security. My health has not been too good, but it's been my own fault. Being homeless has made me appreciate people a lot more. Now I know all people should be treated with respect."

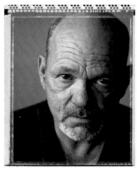

BRIAN LOHSE 53
Houston, Texas
Photographed 4/10/07

"I'm formerly a Republican. Back in 1996 in Houston, Texas, I was sleeping in a field looking at the high-rise apartment that I used to live in. I couldn't believe that a few years earlier I had a nice apartment, I was driving a new car, I had an American Express Card, a line of credit at the bank. I ate at nice restaurants and wore designer clothes. But now, I was sleeping in fields, eating at soup kitchens, getting clothes with vouchers, and riding the metro. It did not make

sense to me. But my problem wasn't logical, it was spiritual. I didn't think there was any such thing as a homeless Republican, but the Lord will get your attention one way or another."

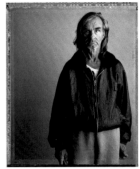

ROBERT SPICER 61
Elmira, New York
Photographed 4/29/08

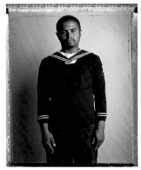

OSCAR PALACIOS 29
San Miguel de Allende, Mexico
Photographed 9/11/07

"When I was a kid, I came to the US to get money. My dad died when I was nine years old. I didn't have much school. I ran away from my house. Even though my sons were born here, their mom took them back to Mexico. I do day labor and I try to send them $200 a month."

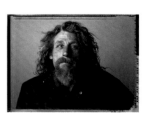

TROY LANIER 40
Dixon, Illinois
Photographed 11/22/06

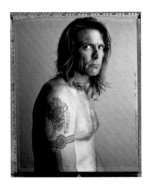

CHARLES TRUCKER 45
Minneapolis, Minnesota
Photographed 4/1/08

"I've been in Austin since 1973. I am forty-five years old. For the last twenty years I have been a user and a dealer of meth. Two years ago I quit selling and dealing and gave my life to Jesus. I am now living at a homeless camp outside of Austin. In my mid-twenties, my marriage broke up. I lost my business and hit bottom. I sold drugs and stayed a functional addict."

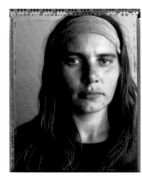

CHRISTINA MCCARTY 29
Austin, Texas
Photographed 11/26/08

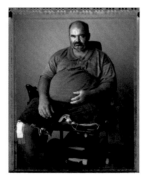

WILLIAM LOAR 51
Austin, Texas
Photographed 7/31/07

"I lost my leg in a knee replacement operation fifteen years ago. I've been homeless almost as long. I'm on two different pain meds and the street people try to steal them

from me. I dropped out of Austin High in the eleventh grade when my father passed away. I came from a good family but my mother got breast cancer and died. I'd love to be off the streets with a place of my own. Even with only one leg, I get around a whole lot—I can bathe myself and dress myself. My dream is to get a prosthesis for my left leg."

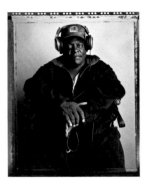

BOBBY BOLTON 56
Fort Worth, Texas
Photographed 11/26/08

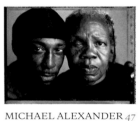

MICHAEL ALEXANDER 47
Dallas, Texas
SHIRLEY ERSKINS 54
Brownwood, Texas
Photographed 10/2/07

Shirley: "I lost my eye in a car wreck riding in a Ford pickup truck in 1997. The truck I was riding in hit a tree going ninety-five mph. My eyeball came out of the socket and I was dead on arrival at the hospital. I told my mother not to always get me out of trouble, but to let me lie down in it. Mother passed away while I was in prison. I got caught forging checks."

Michael: "We met three years ago. I liked the way she looked. We've stuck together like two peas in a pod. Shirley is my sister, my mother, everything. All my life, I've liked older women."

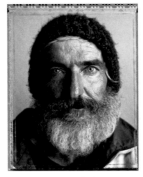

JERRY FREEMAN 50
Haines City, Florida
Photographed 4/1/08

"I left Florida. There are too many hurricanes there. I'm trying to pick up some day labor now. Right now I live in a camp with one other guy."

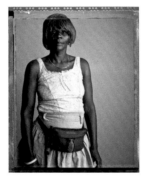

CASSANDRA BROOKS 44
New Orleans, Louisiana
Photographed 9/23/08

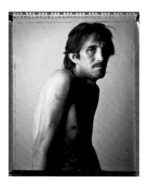

CHESTER PHILLIPS 33
Miami, Florida
Photographed 8/14/07

"I've been in Austin since 2004. It is slower than Miami. I've been homeless off and on since 2000. Everywhere we sit, the cops come by and make us move. You can't sleep safely and soundly because the cops come by and give you a

ticket. I can't go back to sleep once someone wakes me up. My dad died when I was six. Mom just had boyfriends after that. I started doing heroin when I was twelve. It got to be a big problem and my family disowned me when I was fourteen. I've quit drinking and doing heroin and cocaine since last October. I'm even trying to stop smoking cigarettes."

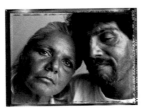

JOANN HERNANDEZ *42*
San Antonio, Texas
DAVID CABALLERO *41*
Scranton, Texas
Photographed 9/23/08

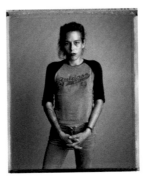

MICHELLE ESPINOZA *33*
Austin, Texas
Photographed 10/16/07

"I've been on heroin and crack for ten years. My life has been filled with violence. My roommate, a guy, shot himself with an AK-47. And a year ago, my boyfriend, Ryder, and I were going to score some crack. Ryder went to the dealer's house while I went to get the money. While Ryder was waiting, a robber came by and stabbed him. Now, I live in a homeless camp."

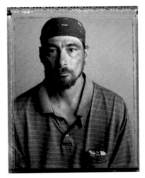

MICHAEL SCHRAMM *44*
Chicago, Illinois
Photographed 4/8/08

"I've moved around a lot. When I turned thirty-two, I rested my head in Austin. Since then my life has been fortunate."

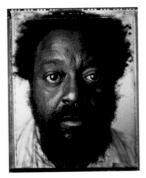

PAUL RANCE *50*
Jackson, Mississippi
Photographed 4/10/07

"I keep my eyes open and stay away from evil."

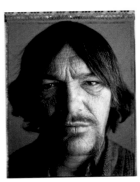

TRAVIS RUSHING *39*
Orange, Texas
Photographed 2/26/08

"I have Acromegalia, a growth hormone disorder. The same as Andre the Giant. I've had two heart attacks and I've just had bypass surgery. I'm disabled so I don't work. I sleep under the interstate at Seventh Street. I just have a sleeping bag and a blanket. I plan to get a ticket on Amtrak and get out of town. Wherever I go my disability check follows."

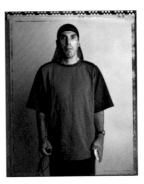

MICHAEL MAYES *40*
Fort Worth, Texas
Photographed 4/7/09

"I'm trying to look for a job but no one wants to hire me. Last time I was on drugs was 1984. It has been twenty years since I've had anything in my system. I have a tent in the woods. I don't show anybody where I'm at. It does get lonely—I'm always reading the Bible. I meditate on God. Sometimes I do get a job, usually trash clean-up, or landscaping."

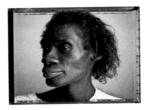

HARTFORD GOODEN *41*
Hooks, Texas
Photographed 7/8/08

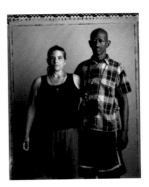

TERRIE HANSHEW *43*
Elwood, Indiana
KENNETH DIXON *55*
Houston, Texas
Photographed 7/8/08

Terrie: "I've been in Austin for eighteen years and homeless for the last four. I went through a divorce and got messed up on drugs. I usually sleep at the recycling center at Interstate 35 and Ninth Street. About thirty people a night sleep there. We get to stay there as long as we clean up."

Kenneth: "My parents died in '86 and I've been on my own ever since then. I live outdoors and it is hard to meet my needs . . . hygiene and all. A lot of people don't think I'm homeless by the way I dress. But I'm just trying to show the respect I have for myself. When I get a clothes voucher, I pick a good outfit to make a good appearance."

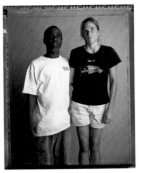

DARRYL JOHNSON *43*
Louisville, Kentucky
TONI JOHNSON *34*
San Clemente, California
Photographed 8/28/07

Toni: "We've been married three years legally, but we've been together six years. I came to Austin with my daughter's father. My daughter is fourteen. She lives with her dad in Monahans, Texas. I have six children total. One of my daughters was murdered. She was only nine weeks old. Her dad got put in Huntsville for forty years. People call me names and think I'm out there prostituting."

Darryl: "We met at the Salvation Army. I got to Austin by working for the Ringling Brothers Circus. I sold cotton candy. I was with the circus for five years. I quit in Austin and then went to work for a labor pool. We've been sleeping under a bridge at I-35. It's not bad. The cops don't bother you. But I hate the sweeper truck, they blow stuff all over you."

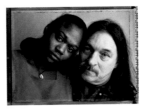

CHARLENE LEE *21*
Austin, Texas
CHIP SINGLETON *45*
Houston, Texas
Photographed 2/26/08

Chip: "I met this little woman about four years ago. Been with her ever since. Can't cut her loose. Been through hell, the both of us."

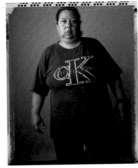

DAWN JOHNVIN
Photographed 11/22/06

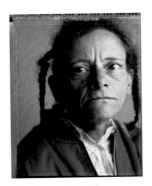

TERESA WAGNER *45*
Boulder City, Nevada
Photographed 4/7/09

"I started doing drugs in 2001 — crack. I quit for a while. I've never done more than eleven months in jail. It was for possession of crack. My husband is at home in Dale, Texas. He doesn't do nothing—just sits around. I'm just trying to make it until next Monday when I get a bed from the Salvation Army. I lost my bed when I relapsed three months ago. I'm praying that I can quit. It is depression that sends me back to crack. I relapse. I don't think too highly of myself. I don't think of hurting anybody except myself."

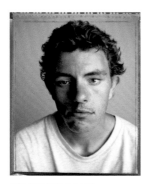

JAMES MORGAN *21*
Brownwood, Texas
Photographed 8/28/07

"I moved to Austin because I was having family problems. I had my wallet, pills, and clothes stolen from me. I live at the ARCH and on the street. I'm bipolar and schizophrenic. I have no income. I work a week and then get fired. I just got out of jail for aggravated sexual assault against my sister. At the time she was four years old. My mom pressed charges. I assaulted my sister multiple times. I regret doing it. I was in jail from ages thirteen to twenty-one."

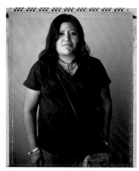

ESTER MORENO
Photographed 11/22/06

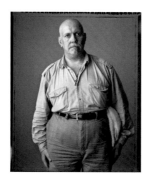

JOEL RHODES *46*
Memphis, Tennessee
Photographed 4/10/07

"I've been homeless for over five years. I broke my back and was paralyzed, but the Lord healed me and let me walk. I was depressed being out on the streets; I was hopeless."

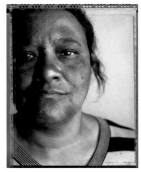

JUDITH MARIE CARREON *46, Chicago, Illinois*
Photographed 4/7/09

"I was divorced two years ago after being married for thirty years. I used to have good things—I could shop and I had a car. I don't have alcohol or drug problems. I'm just a divorcée."

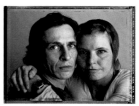

BRÜK KEENER *32*
Japan
ROBIN DRAPER *36*
Buffalo, New York
Photographed 2/26/08

Brük: "I moved from England to Houston when I was eighteen. I then proceeded to put every drug known to the human race into my body. I've been to jail several times—for selling and owning. I have four felonies. The longest stretch I've done is thirteen months and probably I've been in a total of three and a half years. I met Robin two years ago. We got together one year and twenty-two days ago. She asked me if I would stop injecting drugs and I asked her if she would stop practicing witchcraft and I haven't placed any limits on her since."

Robin: "I grew up in Houston. I went to a rehab in Kyle, Texas, for crack in June 2007. I was on a freeway on my way back to Houston and we looked to the right and Austin was just fifteen miles away. So we came to Austin. On the first block I made twelve dollars panhandling and by the second block we

were smoking crack again. It was shocking how fast we found the drug. We started all over again, the same cycle again, just another city. I've tried everything. . . . AA, friends, rehab . . . I have even tried to cast spells and use witchcraft to quit but nothing works."

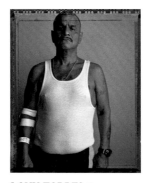

LOUIS TORRES *50*
Houston, Texas
Photographed 9/9/08

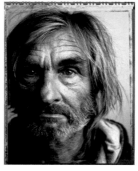

ROBERT SPICER *61*
Elmira, New York
Photographed 11/26/08

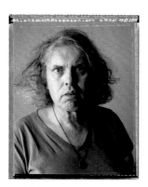

LAURA TANIER *52*
Shiprock, New Mexico
Photographed 7/31/07

"I'm fifty-two years old. I've been living in Austin for the last forty years. I've been sexually assaulted, and I had a stroke. The stroke happened on a city bus. The driver called EMS and they took me to South Austin Hospital. I was there for three weeks. I became depressed and

undependable. I lost my job and then my house. Then I was on the streets. I've been recovering from the stroke. Tomorrow night I will sleep in front of the First Methodist Church. I sleep there every Monday and Wednesday. On Saturday nights I stay in the Bluebonnet area." (Laura Tanier died in 2008.)

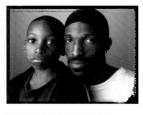

RICHARD LEWIS III *8*
RICHARD LEWIS, JR. *28*
Photographed 11/22/06

Richard, Jr.: "I have a job at a pizza place, but it doesn't pay enough to make ends meet."

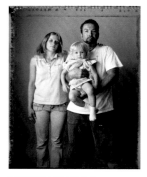

LESLIE MCADOO *27*
JOE MCADOO *40*
NAVAEH MCADOO *2*
Photographed 7/31/07

Joe: "We got flooded out in Jonestown. We've been living under bridges. We've stayed at a couple of churches—sometimes we even slept in vans . . . all five of us. We got into a shelter. I have a job and a roof over my family. Leslie and I have been married for ten years."

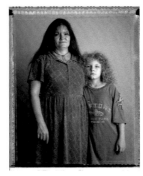

LAVONNE OXNER *39*
Houston, Texas
KYLE OXNER *9*
Austin, Texas
Photographed 9/11/07

"I've lived in Austin for eleven years to be closer to my mom who is disabled. I had to give up possession of the house I lived in for six years. The landlord broke the lease. My mom had a stroke five months ago. She was released into my care. Since August we have been at the Salvation Army shelter. I just signed papers to have my mother put into a nursing home."

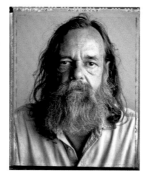

DALE KING *56*
Wichita, Kansas
Photographed 4/15/08

"I'm not sure where I was born. I was found in Wichita, Kansas, when I was fourteen months old. I'm adopted. I was fifteen when I left home and went to California. I traveled around and got to Austin in '77. I was just turning twenty-five. I was on the road for ten years. I did odd jobs. I left town in '97 looking for cheap rent."

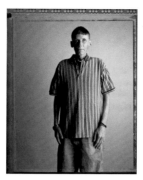

MICHAEL BUTLER 36
Mandeville, Jamaica
Photographed 11/26/08

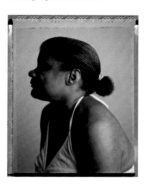

CONNIE THOMPSON 44
Austin, Texas
Photographed 4/29/08

"I got a TV, but I need a new TV. I got a boyfriend named Mike. He doesn't have a job. I like to sit down and watch TV—I watch Christian services and good movies . . . like shoot-the-gun movies. I don't get scared as long as my boyfriend is with me."

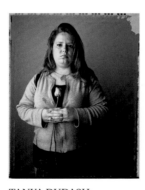

TANYA DUDASH
Photographed 11/22/06

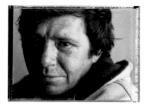

RICHARD SMITH 45
McSherry, Pennsylvania
Photographed 4/29/08

"I got shot with a .22 pistol. My momma-in-law shot me in August 1989. The slug was lodged on my spinal column. I was fighting with my wife all of the time. I was a violent alcoholic. I was making good money, but I messed around with other women. I told the police the shooting was an accident. I always keep a sleeping bag on my wheelchair."

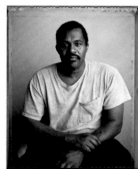

PATRICK HAGGER
Houston, Texas
Photographed 2/26/08

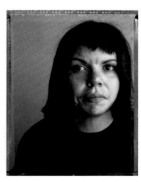

RACHEL MURDOCK
Photographed 4/1/08

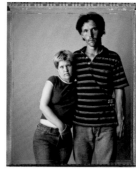

MIRANDA PRIMM 22
Rutland, South Dakota
RONNIE BEATTY 26
Pinckneyville, Illinois
Photographed 6/14/07

Ronnie: "We're girlfriend and boyfriend. We met at the Salvation Army and we hooked up. It's hard to find places to take showers. We sleep out in public. We don't have a tent, but we have a blanket and pillow. That's all I need. Most of my neck and chest were burned when I was eight months old with boiling water."

Miranda: "When I met Ronnie I was upset and crying. It took three days before I would talk to him. I'm a shy person, but Ronnie is the type of person you want to talk to and share things with. My parents kicked me out when I was thirteen; just now we are starting to talk again. I'm a diabetic. I get my insulin from Brackenridge Hospital. I fractured my ankle looking for a job and now I have a diabetic ulcer on my foot. It is hard to keep it clean living outside."

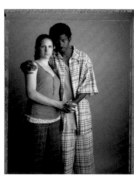

KARRIE MCADOO 18
JEREMIAH GREEN 18
Photographed 7/31/07

Karrie: "All five of us, my mother, father, sister, and Jeremiah, were living in a van, homeless. We were hot and there were mosquitoes. Jeremiah and I got our GEDs. We met in the job corps in San Marcos. We liked each other right away. We are living in a transitional home."

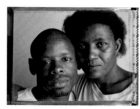

DAVID FILES 38
Austin, Texas
ELLA FILES 38
Memphis, Tennessee
Photographed 9/11/07

Ella: "We are planning on getting married. So I am claiming his name already. I like David's heart. I can talk to him about anything and he makes me smile. I have a twenty-year-old girl, nineteen-year-old son, and fifteen-year-old daughter. My fifteen-year-old just won the teen pageant in Fairfield, Texas."

David: "We met at L.C. Campbell Elementary School in the third grade. When my marriage didn't work out, Ella moved in. We help each other survive. I'm trying to get a job, but when you get turned down and turned down, you just want to quit. Sometimes we sleep in the park. Last year we slept in a deserted truck."

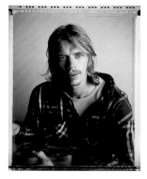

DAVID KRAMER 24
Corpus Christi, Texas
Photographed 11/20/07

"I'm a musician. I've had my guitar stolen again and again. I have acquaintances but no one I call a friend. Every now and again I get in touch with Mom and let her know I am all right."

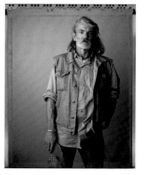

WILLIAM LANGLEY 51
Photographed 11/22/06

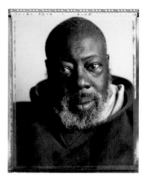

EDDIE RAY WHITE 64
Lubbock, Texas
Photographed 11/26/08

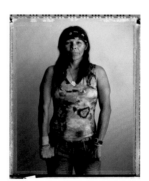

ANNA MARIE TAMAYO 48
South Dakota
Photographed 4/1/08

"I am an Apache Cherokee born in South Dakota and raised in San Antonio. I've spent time in jail for things I'm not proud of, but I am a survivor. I have six children, eleven grandkids and two great-grandkids."

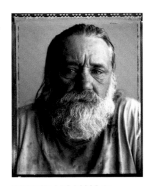

DANNY ALLMAN 65
Birmingham, Alabama
Photographed 9/23/08

"Take me, I work for a good outfit. I was surprised I got hired knowing that I'm homeless. McKinney Drilling is a good outfit. They take care of their workers. I live in the woods. I make $10 an hour. The cheapest crackhead motel in this town is $250 a week. Making $10 an hour . . . I'm not eligible for food stamps. I have to take Plavix and Lipitor and they are expensive drugs. A poor man can't make it on a little wage. I feel sorry for the working poor today. Our country has to change. People got to realize that a lot of folk are just a couple of paychecks away from where I'm at."

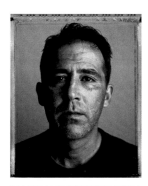

MARK ANTHONY DRAINE
41, *Central Falls, Rhode Island*
Photographed 10/16/07

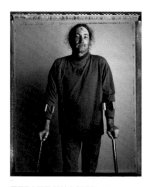

FERNIE WALKER 49
Roswell, New Mexico
Photographed 9/11/07

"I was born in New Mexico, but my family's roots are in South Carolina. I've been in Austin on and off for the last thirty-one years. I have asbestos cancer. I have to use crutches because I have three herniated disks. I stay in a camp across from Chuy's on Barton Springs. I have a tent there. I've been homeless since 1998. I did time for hot checks and marijuana. With a felony conviction, I can't get an apartment, even if I had the money."

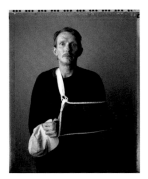

FLOYD STONE 45
Photographed 11/22/06

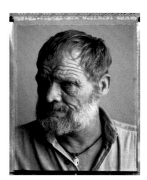

RANDY BIRCH 49
Photographed 4/29/08

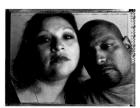

ANGIE RAMIREZ 39
Austin, Texas
ISAAC VALDEZ 36
Houston, Texas
Photographed 7/8/08

Isaac: "Angie asked me to marry her and she has proven more to me than any other woman. This is my first marriage. Angie and I are going through the courts first. Angie has accepted me for

what I am and not for what I had. I was a drug addict and alcoholic. Angie showed me a better way in life. She took me away from the bad things."

Angie: "I met Isaac at the Salvation Army where I was doing my community service for traffic tickets. I let the tickets go and it became too much money. I have three kids, Matthew, twenty, Alvino, eighteen, and Zachary, sixteen. My kids come first. I saw Isaac was different from everyone else. I didn't think he was homeless."

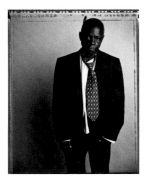

ROY CALDWELL 53
La Grange, Texas
Photographed 8/28/07

"I have a billion sisters and babies. I've been on a bus trip to Florida and Paris. St. Mary is my wife dot com Austin, Texas. My real name is president of the union and movie star. I live on the street. Christ gives me this suit. He made my clothes. St. Mary is my wife; I married her in the church in Topy. I sing songs 'Holy Holy' and dot com Austin, Texas. Everyone should ride the bus to Hawaii. I married a gypsy woman; her name is Diane Caldwell. She is Spanish. She has a gold diamond in her cross."

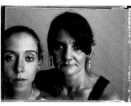

AMELIA STOCKER 22
STACEY TYLER 42
Shreveport, Louisiana
Photographed 4/1/08

Stacey: "I've been on crack for about a year. I just got back together with my daughter, Amelia, three weeks ago. We had been out of touch for a year."

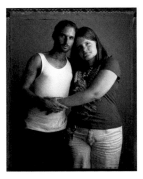

STERLING ROE 24
Austin, Texas
JULIETTE ROE 23
Norfolk, Virginia
Photographed 9/9/08

Sterling: "I was born and raised in Austin. I grew up having trouble with drugs and alcohol, but I finally changed when my daughter was born and gave me the strength to move on from my past."

Juliette: "I just got my first-ever job three weeks ago. I work at Target. It is a good feeling to know me and my husband pulled ourselves up from obscurity and hardships and are able to provide the type of life our daughter deserves and also the type of security she needs financially and emotionally. I don't feel bad about the homeless days, though; I never would have met my husband and changed my life for the better."

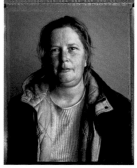

KIMBERLY PERKINS 37
Greenville, South Carolina
Photographed 2/26/08

"I traveled from Knoxville to come to Austin. I got here three months ago. It was

cold in Tennessee and the job I had was seasonal. I was ringing bells for the Salvation Army. I've applied to be a security guard. When an opening comes up, I'll take a drug test and then get my job. I met some people who were living in a camp. I moved from the Salvation Army to the camp. I was in the streets before that."

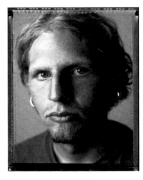

TREY STRAHAN 20
Hattiesburg, Mississippi
Photographed 8/14/07

"I live in a camp in Northeast Austin. I've been there for a week. It's hot, but we eat well. We just had fajitas. Tomorrow, I paint a house. A guy asked if we needed a job and we laid grass. We got paid, but it is not about the money. I need something to put meaning in my life. I met my dad for the first time when I was seven and didn't see him again until I was thirteen. I dropped out of school at fourteen. I've been doing heroin since I was fifteen. I'm off heroin now—last year was hell."

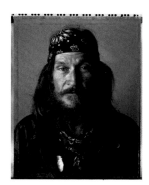

ROBIN MURPHY 48
Photographed 11/ 22/06

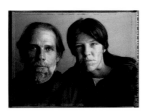

MICHAEL WELCH 45
Waco, Texas
WILHELMINA NORRIS 32
Waco, Texas
Photographed 2/26/08

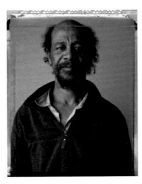

DON MCNULTY
Photographed 11/22/06

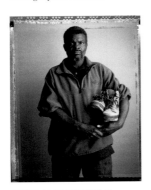

GARLAND NEVILLE 50
Austin, Texas
Photographed 4/29/08

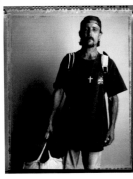

RONNIE WILSON 46
Lockhart, Texas
Photographed 4/7/09

"I was on my own when I was seventeen. I did landscaping to make a living. I planted sod. I've been getting odds and ends of work. I'm not sitting on my tail. I can't stay at the ARCH, they won't let me stay there. I don't have a tent, just a sleeping bag. Sometimes, this guy lets me stay at a filling station. When it rains, I stay dry. It's kind of like a carport.

The main thing I need is a place to live. Off and on, I've been sleeping on the street for years. I quit doing pot and alcohol on my own. I tried rehab before and it didn't work. I'd work seven days a week if I could—I'm a workaholic. I'll even work for room and board—I just want off the street. I'm starting to get stressed out. I walk to take away my stress. I can't get a day-labor job. I don't have an ID—it got stolen out of my backpack. When I lose my ID, I got to go to DPS and have my aunt bring my birth certificate up from San Antonio and then I get a new ID."

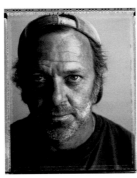

RAY BELL 46
New Braunfels, Texas
Photographed 4/15/08

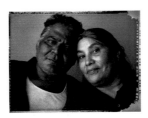

TONY CARMONA 53
Houston, Texas
LINDA CARMONA 54
Houston, Texas
Photographed 11/22/06

Linda: "Tony went to jail for assault and we were separated for two years. I thought I'd give him one more chance. I didn't know where we would sleep every night. I was trying to care for Gordy [their adopted twenty-six-year-old son]. He had a choice of his addiction or us. Tony chose his addiction . . . not us. [But they reconciled and have been together for many years.]"

Tony: "I have the number '13½' tattooed on my chest. I got it done in prison. It means twelve jurors, one judge, and half a chance."

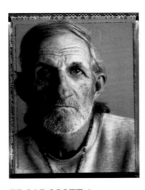

EDGAR SCOTT 60
Baytown, Texas
Photographed 4/15/08

"I go by Eddie. I have bronchial something. I thought I might have pneumonia. The doctor said it would be a month before I am well, if I quit smoking. I live outdoors in a tenant camp. It is OK as long the wolves and coyotes don't come around. One was howling at me the other night. I got a machete and a long stick to keep them away. No one lives in the camp except me. I've been living alone for a good two months. I got food stamps and I use them to get sandwiches. I try and eat at least twice a day because I lost a lot of weight. At night I lie in bed and listen to my radio. I wake up every day and just walk around. I don't know how long I've been in Austin. Maybe it was when I was a kid, say two or three years old. My memory isn't good due to my alcoholism. I can't remember after 2000 but I think my daughter is eight years old unless I'm getting mixed up. I still drink a little but not as much as I used to—I don't have the money."

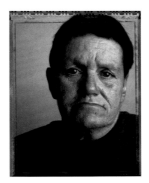

DONNA ELLIS 59
San Antonio, Texas
Photographed 2/10/09

"I threw away a white plastic bag. I believe it was laundry detergent. But the police thought it was drugs. They didn't arrest me. I don't think there is a warrant. It would be on my date of birth. Rent on PO Box 1173 Laredo is due. But I question whether I should keep paying rent on a PO box when I'm denied a key." (Non-sequiturs)

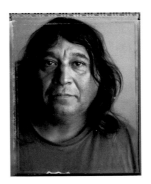

CHRIS TAYLOR 54
Brownsville, Texas
Photographed 11/26/08

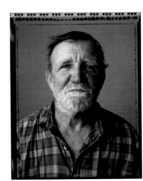

CHARLES MAYFIELD 58
Houston, Texas
Photographed 4/10/07

"I lived under a bridge for seven months. I lived with mosquitoes and small animals."

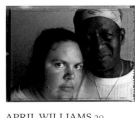

APRIL WILLIAMS 29
Plano, Texas
ROLAND WARE 56
Chicago, Illinois
Photographed 11/26/08

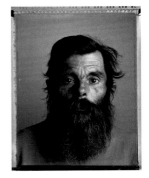

STEPHEN ROBERT BLAIR
53, Venice, California
Photographed 10/2/07

"I don't have any ID. I have all the paperwork to get a birth certificate. I've lived most of my life in Venice, California. I had a good job—cooking as a chef. But I got to my job one hour late one day, and my boss gave my job to another guy. I've been homeless for fifteen years. I talk to my mother every once and awhile. She lives in Fort Worth, but I haven't seen her in twenty years. I go to a pay telephone every other day at 5 p.m. If the phone doesn't ring in five minutes, I know Mother is not going to call. But she calls most of the time."